IMAGES
of America

HERMOSA BEACH

This 1933 beauty contest on the beach epitomizes to some degree Hermosa Beach's time-honored status as a place that's a state of mind for residents and visitors alike. It's a place for events and things that perhaps don't mean much in the scheme of things. However, its pastimes and beauty, and the seaside languor that it has come to represent, can be as essential to the body and spirit as the rat race and family worries are to everyday life. (Courtesy Hermosa Beach Historical Society.)

ON THE COVER: The Los Angeles County Lifeguards have kept Hermosa Beach safe for nearly a century. Every summer, vacationers and other beachgoers at Hermosa Beach owe their lives to these vigilant guards. Here a lifeguard and companion pose for a casual snapshot in 1925 in front of the beginnings of what would become the Surf and Sand Club, and then a longtime city landmark, the Hermosa Biltmore Hotel. (Courtesy Hermosa Beach Historical Society.)

ACKNOWLEDGMENTS

This book would not have been as pictorially rich and varied and its depth of information not as accurate without the essential help and guidance of the Hermosa Beach Historical Society. John Hales of the society has been compiling data on the city for years. His collection, which is, in essence, the society's archive, is invaluable for anyone wanting to learn more on the structure, history, and people who have made Hermosa Beach into one of the jewels of the Pacific Coast. Patricia Gazin's pioneering work, *Footnotes on the Sand*, was of great help for time, place, and people details. What appears on the following pages is in some cases a distillation of John Hales's and Patricia Gazin's work. Roger Creighton was generous in supplying his own archive to this effort, another for the former mayor in a continuum of lifelong involvements regarding the city, its resources, and the beach. This book is partially a reflection on the civic-minded efforts of these folks and others who have walked the sand in bygone generations.

The authors want to thank Rick Koenig of the HBHS for his good will, extra effort, and cheerful collaboration. Other HBHS members' dedication and work contributed to the following pages. Also, the Kerwin family in general, whose ancestors kicked the sand in Hermosa practically back into the 19th century, deserve special thanks. In particular, they are Scott T. Kerwin, and Ted and Dottie Kerwin. The Seawright family also deserves special mention, especially Annie Seawright and Corey Newton, Roy and Bunny Seawright. The knowledge and generosity of Eric Fankhauser and Ken Poston of the Los Angeles Jazz Institute at California State University, Long Beach, helped the authors sort through Howard Rumsey's photograph collection of The Lighthouse. Both *The Beach Reporter* and *Easy Reader* made significant contributions to the following pages. James Osborne generously donated both his knowledge of South Bay history and vintage photographs. Others whose contributions made this book as rich as it is include Bob Brigham, Kevin Cody, Jan Dennis, the Fisher family, Sam Gnerre, Leroy Grannis, Donald Hales, Robi Hutas, David Lucero, Joanne Mallillin, Mike Schweid, Christine Talbot, and Carol Tanner.

CONTENTS

Copyright © 2005 by Chris Miller, Jerry Roberts, and the Hermosa Beach Historical Society
ISBN 978-0-7385-2974-5

Published by Arcadia Publishing
Charleston SC, Chicago IL, Portsmouth NH, San Francisco CA

Printed in the United States of America

Library of Congress Catalog Card Number: 2005923003

For all general information contact Arcadia Publishing at:
Telephone 843-853-2070
Fax 843-853-0044
E-mail sales@arcadiapublishing.com
For customer service and orders:
Toll-Free 1-888-313-2665

Visit us on the Internet at www.arcadiapublishing.com

The Biltmore Hotel was the largest high-rise structure in downtown Hermosa Beach. For many years, it was the locus of social activity and a destination point for world travelers as well as the weekend Hollywood crowd, and anyone who came to enjoy "Beautiful Beach." It's also a focal point recurring for the reader to navigate pictorially through this book. This photograph shows the building in 1928 when it was still known as the Surf and Sand Club. (Courtesy Hermosa Beach Historical Society.)

IMAGES
of America

HERMOSA BEACH

Chris Miller and Jerry Roberts
with the Hermosa Beach Historical Society

INTRODUCTION

The original people who lived in what became coastal southwestern Los Angeles County were descended from a group of ancient hunters who migrated from Asia across the Bering Strait as early as 10,000 years ago. Sometime prior to 2,000 B.C., another group of people, the Uto-Aztecan (Shosonian) group, known today as the Gabrielino tribe, began to inhabit the area.

Juan Cabrillo, a Portuguese captain sailing under the Spanish flag, was believed to be the first European to explore California's coastline in 1542. The first land expedition was made under the command of Gaspar de Portola. In 1769, Upper and Lower California came under the control of the king of Spain. By 1784, the granting of the lands for ranchos in the Los Angeles area had begun. When Mexican independence was finally achieved in 1822, some 30 rancho concessions had been distributed.

One of those early Mexican land grants was the Sausal Redondo, or Round Clump of Willows. The 10-mile ocean frontage of this rancho included what is today's Hermosa Beach. The rancho was received in 1822 by Antonio Ygnacio Avila as a provisional grant by Capt. Jose Arrega, the commandant of Santa Barbara. The Sausal Redondo oceanfront was comprised of the present cities of Hermosa Beach, Manhattan Beach, and El Segundo, and portions of the Marina del Rey section of Los Angeles to the north and Redondo Beach to the south. The rancho also included what today constitutes the cities of Hawthorne, Inglewood, and Lawndale.

A decades-long land dispute over the Sausal Redondo continued after the land changed nations again. The 1848 Treaty of Guadalupe Hidalgo ceded Upper California to the United States of America. Two years later, the State of California was admitted to the union. Avila was eventually acknowledged as the legal landholder of the rancho after the district court ruled in his favor in 1856. After Avila died in 1858, his heirs sold the rancho lands.

At one time, in the late 1800s, Canadian Daniel Freeman owned much of the rancho and grew barley and other grains for the grazing of sheep, horses, and cattle. In 1900, 1,500 acres of the original Sausal Redondo was bought from A. E. Pomeroy by purchasing agents Burbank and Baker for $35 an acre. Burbank and Baker worked on behalf of water rights buyers Sherman and Clark, who organized the Hermosa Beach Land and Water Company in anticipation of both the growth of the City of Los Angeles and a resort settlement along the coastline. On April 1, 1901, Clement L. "Bob" Reinbolt, who, in later years, liked to refer to himself as Hermosa's first settler, moved onto the acreage with a grading and surveying team for the Hermosa Beach Land and Water Company.

No one person seems to have been identified with the naming of the beach as Hermosa, which is Spanish for beautiful. But few in succeeding years have questioned the moniker's accuracy. With a sight line to Santa Catalina Island off the point of Palos Verdes Peninsula to the southwest, a

gently sloping beach into a surf with few riptides, a sunset of consistent orange hues, and a fine sand base, Hermosa Beach certainly represented its name.

The first official survey of the beach was made in 1901 to lay out the boardwalk along the Strand as well as Hermosa and Santa Fe Avenues. A water supply was located the same year near the Manhattan Beach border on the old Duncan ranch, and a storage tank was built on top of the dunes. In 1904, the first Hermosa Beach Pier was constructed of wood and extended 500 feet into the ocean. In 1913, most of that pier was washed away in a heavy winter storm. It was replaced with a concrete pier topped by asphalt that extended 1,000 feet over the ocean. Hermosa Avenue was the first street to be paved. The Santa Fe Railway was the main transportation connection to other collections of Los Angeles County civilization. By 1904, Santa Fe Avenue (today Pier Avenue) was paved the seven blocks or so up the dunes to the railway depot (located at today's Valley Drive).

On January 14, 1907, even as Pacific Coast Highway still rated as a country lane dappled with sunshine through the eucalyptus canopies, Hermosa Beach became the 19th incorporated city in Los Angeles County. In 1914, the boardwalk that had a habit of disappearing out to sea in chunks during severe winter storms was replaced with a cement Strand. And through all of this, the cottages and homes had been going up, one by one, throughout the new beach community.

One

PIONEERS AND BEGINNINGS

Shakespeare Beach was located at the city's northern border with Manhattan Beach, where the Pacific Electric Red Car Line came into the city. When the Shakespeare Tract was divided into parcels, the streets were named after noteworthy poets such as Homer, Longfellow, and Tennyson, to name a few. This was an attempt to create an artists colony in Hermosa Beach. The gentleman depicted here on Shakespeare Beach beside a classic Red Car is one of Hermosa Beach's influential city fathers, Ralph Matteson, who accrued extensive land holdings in the South Bay area. Trained as a naturalist, Matteson tended an elaborate flower garden for decades at 1901 Manhattan Avenue, Hermosa Beach. (Courtesy Roger Creighton.)

The Strand's predecessor was the Hermosa Beach Boardwalk, built in 1908, and rebuilt many times. The Pacific Ocean had a habit of claiming the boardwalk in raft-like chunks during winter storms until the concrete Strand was built. (Courtesy Hermosa Beach Historical Society.)

This early map of Hermosa Beach was published in 1915, when the residents of Hermosa Beach numbered just 3,000. Advertising 30 miles of paved streets, Hermosa claimed to be the safest and most quickly improving city on the coast. By 1915, the City of Hermosa Beach proudly announced

The first pier in Hermosa Beach, made completely of wood, was built in 1904 by the Hermosa Land and Water Company. The first pier extended 500 feet out into Santa Monica Bay. At its base was Santa Fe Avenue, later changed to Pier Avenue. That same year, Santa Fe was paved up the dune all the way to Railroad Avenue, which today is called Valley Drive. (Courtesy the Hermosa Beach Historical Society.)

a newly built Municipal Pier, the First Bank of Hermosa, and the Hermosa Beach Grammar School. Numerous residents from all walks of life were beginning to call Hermosa Beach their year-round home. (Courtesy Hermosa Beach Historical Society.)

This is a late 1910s photograph of the corner of Santa Fe (later Pier Avenue) and Hermosa Avenues, looking northwest. The horseless carriage seen zooming southward was headed toward Redondo Beach, at a time when the adjacent city to the south was growing into one of the West Coast's biggest beachfront resorts. In this first block of Santa Fe Avenue were the Kerwin Family Bakery and Morse and Morse grocery store. (Courtesy Roger Creighton.)

The first house built in Hermosa Beach was called the Hill House and located just above the present location of Pier and Summit Avenues (Summit is now known as Monterey Avenue). From left to right are, unidentified, Bea Hiss, Bernard Hiss, Mary Hiss, Margaret McClean, George McClean (Bernard McNerney), and two unidentified children. Eva Hiss' brother, Joseph Hiss, was born in this house on April 4, 1907. The first boy born in Hermosa Beach, John Hiss, was born in the house on November 9, 1905. (Courtesy Roger Creighton.)

This early Hermosa Beach house was typical of many of the beachfront homes along the coast in the first decades of the 20th century. They were small, wood-frame structures built for functionality: sleeping, eating, and staying warm during the cold, wet winters. Occasionally earlier settlers to the city were disappointed after reading descriptions of Hermosa in terms of orange groves and eternal sunshine, instead of the desolate windswept dunes they found. Some of these beach cottages still survive in neighborhoods of Hermosa and Redondo Beaches. (Courtesy Hermosa Beach Historical Society.)

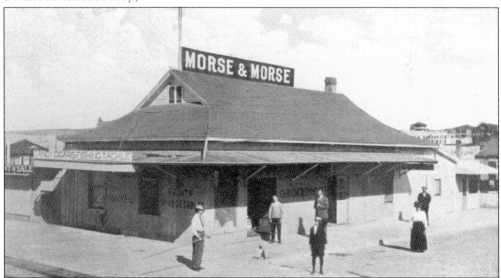

D. A. Morse and Bernard Morse operated the first grocery store in Hermosa Beach, located on the north side of the first block of Santa Fe (Pier) Avenue. The Morse brothers used a horse cart to deliver groceries and wares to homes throughout the city. D. A. Morse was the city's first official treasurer. By 1908, the grocery store was equipped with the first telephone in town. The store was a focal point of social activity and both brothers remained deeply involved in civic activities for a generation. (Courtesy Roger Creighton.)

Mary Emma (Hiss) Kerwin and her first-born, Ellen Mary, are seen here in 1911 standing in front of the first Kerwin's Bakery at 31 Santa Fe Avenue, Hermosa Beach. The Kerwin family eventually grew to the then proper Irish-Catholic family size of nine siblings in addition to Ellen Mary. (Courtesy Kerwin family.)

The Berth Hotel, which became The Breakers and occupied the location of the Sea Sprite today, is depicted in 1909. The location was just across the street from a large popular bowling alley that existed well into the 1960s. The spot eventually became the present-day Scotty's Restaurant, situated on the Strand at Tenth Street. Jean's Drink Stand stood next door making popular blended fruit drinks decades before their perceived popularity. Later that location became Taco Bill's Mexican restaurant and, now, Hennessey's Tavern. Mrs. Theo Berth was denied a liquor license for the hotel in August 1910, and Hermosa remained dry until prohibition was repealed. Locals made trips into Redondo Beach to buy alcoholic beverages. (Courtesy Roger Creighton.)

This is the original St. Cross Episcopal Church as it appeared in 1909. It was the first church in Hermosa Beach. Prior to its construction, the first church services were held downtown in the old Hermosa Beach Post Office on Sante Fe Avenue. The St. Cross Church on Summit Avenue (now Monterey) was dedicated on July 11, 1909, after Burbank and Baker donated the land for it. Sarah Alice Beane, the first postal employee who donated the space in the post office for the initial services, and Fr. Charles H. de Garmo, the vicar of Christ Church, Redondo Beach, were known as the "father and mother" of St. Cross Church—even though one was an Episcopalian and the other a Presbyterian. The church's name comes from the transference of the handmade cross from the post office to the new church. (Courtesy Hermosa Beach Historical Society.)

The parents of early Hermosa Beach town father Ralph Matteson are depicted on the Hermosa Beach Pier with Ralph and Charlotte "Lottie" Matteson, c. 1910. Ralph and Lottie built their first home at 1040 Manhattan Avenue in 1906, when fewer than 20 homes were on the lands of the future City of Hermosa Beach. Ralph, who fought in Native American wars and mined for gold in Mexico before coming to Hermosa, managed Western Fuel Gas and Power Company, which was sold many years later to the Southern California Gas Company. (Courtesy Hermosa Beach Historical Society.)

The Pacific Electric Red Car Line ran parallel to the beach down from Marina del Rey, past Playa del Rey, through El Segundo to Manhattan, Hermosa, and Redondo Beaches. It was a favorite mode of transportation for the Los Angeles and Hollywood crowds to get to the big resort of Redondo Beach. In 1914, Pacific Electric laid stronger rails for bigger trains and ran the line up until 1939, when it discontinued service. The tracks dividing the northbound and southbound lanes of Hermosa Avenue were pulled out in 1941. (Courtesy Roger Creighton.)

Shown here on July 2, 1909, is the electrical switching station that transferred power to move the Red Cars around town. It was located near the present-day Twenty-eighth Street, between the Strand and Hermosa Avenue. The power station switched the electricity generated from the El Segundo Edison plant to the Redondo Beach Huntington plant to propel the Red Cars along Hermosa Avenue. (Courtesy Roger Creighton.)

The inside of Andrews Art Shop, an "Indian trading post" of sorts located on the north side of Santa Fe Avenue, is shown in 1910. Complete with lynx pelts and other game-animal skins and furs, and woven baskets and souvenirs, the store was a Hermosa mainstay. With the close proximity of Hermosa to the port of Redondo Beach, large cargo vessels were off-loading wares from around the world on a regular basis, and shops such as Andrews Art benefited. (Courtesy Mrs. R. R. Murphy.)

The Vetter Windmill, a Hermosa Beach landmark, today rests in Greenwood Park, a small park at the corner of Pacific Coast Highway and Aviation Boulevard in Hermosa Beach. A symbol of the city's past, it was once an integral business icon, erected in 1907 to provide the power to irrigate the hillside flower farms located at Ardmore Avenue and Sixteenth Street. Japanese, Dutch, and Greek immigrants grew flowers in Hermosa, and loaded them often at 2:00 and 3:00 a.m. onto railcars and trucks to be sold the next morning at markets in Los Angeles. (Courtesy Hermosa Beach Historical Society.)

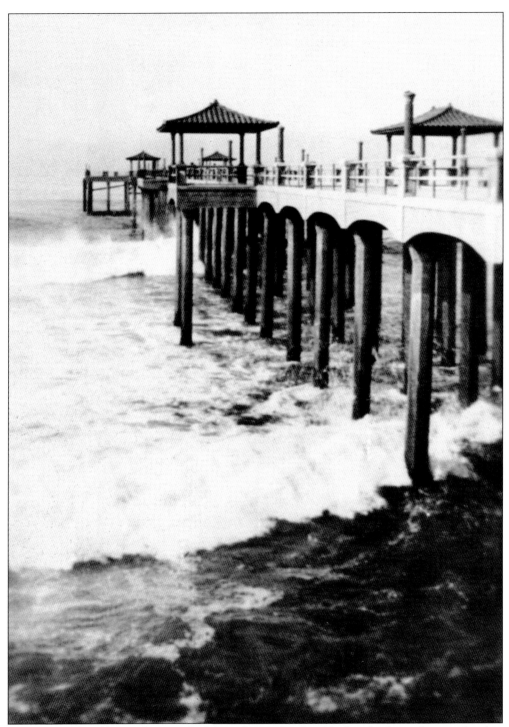

This view of the old pier, photographed from the south side of the beach, shows the pagodas that served as shelters from the sun for fishermen and other visitors. The pier lasted from 1914 until 1961. It was condemned in 1957 after storm damage and demolished in 1961. The new pier, with a $600,000 price tag, was dedicated in 1965. (Courtesy Hermosa Beach Historical Society.)

The dedication ceremonies for the 1,000-foot concrete Hermosa Beach Pier were held in 1914. The pagoda can be seen in the far background of this shot, taken from the Strand north of the pier. After the old wooden pier had been destroyed by storms, the concrete pier gave the little resort community some strong legs on which to stand. (Courtesy Hermosa Beach Historical Society.)

This photograph was taken on August 12, 1914, at the shoreline in Hermosa Beach. It was a very popular summer activity for residents of, and visitors to, Los Angeles and inland areas to take the Pacific Electric Red Car down to Hermosa to escape the summer heat. Perhaps the men would actually loosen a collar button or two. The ocean breezes have always been a great Hermosa attraction. (Courtesy James Osborne.)

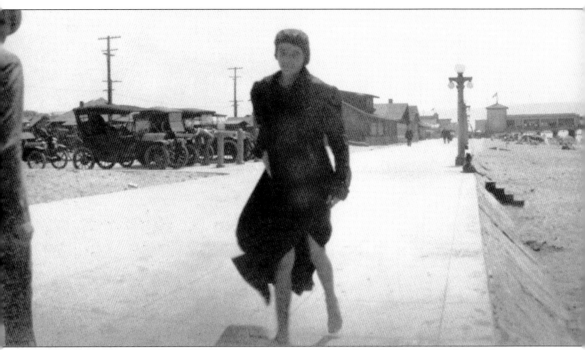

This spring morning shot of the first paved Hermosa Beach boardwalk, which did not have a sea wall like the later concrete Strand, dates to about 1920. Although the woman in the foreground is unidentified, it's likely that she was a resident returning from a visit to downtown Hermosa.

Real estate developers Burbank and Baker, who were retained by tycoon Moses Sherman in the first decade of the 20th century, saw Hermosa Beach as a potential vacation spot and weekend getaway locale for residents of Los Angeles. The developers' vision of Hermosa Beach as an inviting windswept seascape was fulfilled by scenes like this beach picnic. (Courtesy James Osborne.)

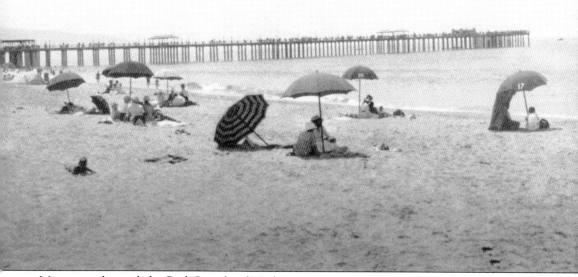

Many people used the Red Cars for their longer transportation needs, and the beachside sidewalk became the easiest way to get around within the city limits. (Courtesy Hermosa Beach Historical Society.)

Among the early families settling in Hermosa Beach were the Reinbolts, Kerwins, and Hisses. Pictured in September 1909, from left to right, are Janetta Reinbolt, Clement L. "Bob" Reinbolt, Emma Hiss-Kerwin, Matilda Reinbolt, Ruby Scoles-Hiss, Barbara Hiss-McGee, and Henry Hiss. Bob Reinbolt accompanied the first surveying crew employed by Burbank and Baker to carve out Hermosa Beach, and preferred years later to characterize himself as Hermosa's first resident. (Courtesy Hermosa Beach Historical Society.)

OFFICIAL MAP OF THE CITY OF HERMOSA BEACH

FIRST - Best paved city in the universe
SECOND - Over $350,000 have been and are being expended in the installation of asphalt concrete
and Warrenite pavement, representing over eighteen miles of improved streets.
THIRD - Over $50,000 have been expended in the erection of new homes in the last year
FOURTH - The only traffic covered beach, having perfect surfing conditions on the coast
FIFTH - Best water for drinking purposes in Southern California according to chemical analysis

22

This 1920s map, which has Hermosa Beach businesses advertising on the wide margins, was printed by the C. Wesley Denning Company of Los Angeles. Many of the early businesses that dominated Hermosa Beach life are evident: Morse and Morse, Reinbolt, Hiss, etc. (Courtesy Kerwin family.)

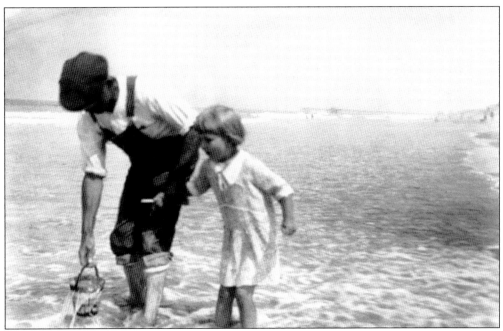

This photograph depicts a timeless Hermosa Beach activity—members of different generations exploring the natural phenomena of the Pacific seacoast. The Hermosa shoreline served as a natural depository of seashells, starfish, California cones, purple olives, and clams of all sorts. (Courtesy James Osborne.)

Charlotte Matteson, left, and a companion are depicted on the beach near the first wooden pier. Their swimming costumes were typical of the early years when women were required to be covered from neck to toe at all times. Many visitors and residents found any opportunity to be photographed near the water's edge as way of documenting for family and friends that they had arrived at the Pacific Ocean. In the early 1900s, this was quite an adventure to accomplish. (Courtesy Hermosa Beach Historical Society.)

Two

MID-20TH CENTURY

The fishing off the Hermosa Beach Pier has always been challenging. However, the challenge to lift the catch was hardly ever more difficult than the day in 1924 when this 427-pound sea bass was caught by Tex Rodgers. Over the years, enormous fish have been caught off the pier and via surf casting. The great variety has included halibut, tuna, sharks, barracuda, and the full gamut of the Pacific's fishery. Whales and dolphins can be seen today from the beach as they travel down the coast. (Courtesy Hermosa Beach Historical Society.)

The Metropolitan Theater is shown here under construction in 1923. The driving force behind its creation was civic-minded banker Ralph Matteson. A bank was located on the site, and the theatre was built around it; then the bank was torn down inside the theatre walls. This formidable building on Hermosa Avenue, just north of Pier Avenue, served as the city's favorite movie theater for almost 80 years. The Metropolitan became the Cove Theater from 1979 to 1981, then the Bijou Theater in 1983. In the latter portions of the 20th century, the building housed *Easy Reader* in upstairs offices. At the outset of the 21st century the theater was closed, restored, and became Gallery C, an art gallery. (Courtesy Hermosa Beach Historical Society.)

The conveyance known everywhere as the Red Car is shown in front of the Pioneer Hotel. Sherman and Clark built the first electric transportation line into Hermosa Beach and called it the Los Angeles Pacific Railway. The Pacific Electric Railroad took it over and built a freight office and passenger station on the northeast corner of Pier and Hermosa Avenues. The tracks this car is sitting on ran down the center of what is now Hermosa Avenue. (Courtesy Roger Creighton.)

Pictured in 1924 is Fred Oder's Garage, the local filling station located at the northwest corner of Santa Fe Avenue and Valley Drive. Prior to Oder taking it over, the station was known as the Hiss Gas Station. The post office is located on the site today. Behind the garage in the early decades of the 20th century was a livery stable and the valley where weekend and summer vacationers often set up a miniature, constantly changing tent city (see Zion Travel Camp, below). Oder was a Kiwanis Club mainstay. He owned an adaptable parade float that was always used as Santa's sleigh during the Christmas holidays. (Courtesy Hermosa Beach Historical Society.)

The Zion Travel Camp was a way station, first for overnight travelers, then for vacationers. It was located behind the dunes on the present site of the Marineland Mobile Home Park. The Zion camp was situated in a natural canyon-like bowl east of Monterey Avenue, north of Pier Avenue, and west of Valley Drive, behind the post office and Valley Intermediate School. The area was also a pasture in which Fred Hiss kept his horses. (Courtesy Roger Creighton.)

One of Hermosa's first families is shown here in a formal portrait in their living room. Pictured, from left to right, are Robert King, Margaret King with her daughter Margaret B. King (mother of Rick Koenig), and Margaret's father, Richard D. King. The family still lives in this home on Manhattan Avenue and Eighteenth Street. (Courtesy King/Koening family.)

The Kerwin children—Jim, Fred, and Ted—are shown at play in 1924, on the family roof at 31 Santa Fe Avenue (later Pier Avenue). A chicken-wire fence kept the kids safe along with the watchful eyes of older siblings and what the family called the real safety precaution, strict Irish Catholic discipline. The Kerwin Family Bakery was a town landmark for generations. (Courtesy Kerwin family.)

In 1923, this group of local residents and city dignitaries check on the construction of the Surf and Sand Club (later the Hermosa Biltmore Hotel). Among them is Ralph Matteson, one of the city's most civically-minded town fathers. Trained in botany, Matteson is the one seen holding the flowers. (Courtesy Hermosa Beach Historical Society.)

The Metropolitan Theater is open for business. The opening night film starred a young boy who later became a Hermosa resident, Jackie Coogan. The son of vaudevillians, Coogan went on to become one of Hollywood's highest paid child stars. Discovered by another longtime Hermosa habitue, Charlie Chaplin, Coogan starred in *The Kid* (1921) with Chaplin. Coogan made millions by the time he was a teenager and helped to create the Child Actors Bill, also known as the "Coogan Act," which set up protections for the finances of child stars. He married and divorced Betty Grable, and worked in his later years playing the part of the cue ball–topped Uncle Fester on the 1960s CBS sitcom *The Addams Family*. (Courtesy Hermosa Beach Historical Society.)

The Bath House on the Strand at Pier Avenue was a Hermosa Beach landmark for generations. It was a popular location to rent bathing suits, beach umbrellas, and lockers for storing street clothes. Visitors could travel into town on the Red Car, change at the Bath House or the Surf and Sand Club, and spend the day at the beach. (Courtesy Hermosa Beach Historical Society.)

The North Hermosa Boardwalk was converted to the Strand. On several occasions, the early wooden boardwalks would wash away with the heavy winter surf. High tides often undermined the foundation. In the early 1920s, replacing the Strand became a regular public works project for the city. After the Strand wall was added, the surf and sand managed to stay on the ocean's side. (Courtesy Hermosa Beach Historical Society.)

In 1924, the First National Bank of Hermosa Beach was authorized by the U.S. Treasury to print its own money. This $5 bill included an image of Benjamin Harrison on the front, as well as an etching of "The Landing of the Pilgrims" on the back. Many cities and states throughout the country were authorized to print and distribute their own money, which was designed by the U.S. Treasury. This bill was found in the cornerstone of the Biltmore Hotel when it was torn down in 1969. (Courtesy John T. Hales.)

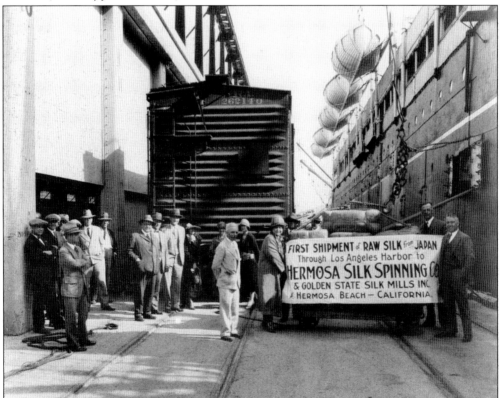

In 1920, the first shipment of raw silk arrived from the Orient via cargo ship into Los Angeles Harbor. It was transported by train up to Los Angeles, then down to the Hermosa Silk Spinning Company, located on a railroad spur off the Santa Fe line at Pier and Ardmore Avenues. (Courtesy Hermosa Beach Historical Society.)

The Hermosa Silk Spinning Company is shown during production. Situated at the corner of Santa Fe and Ardmore Avenues, the factory produced thousands of yards of silk monthly. The factory continued for years at that location, then became Trader Al's. After the factory was torn down, the entire corner became a shopping center. (Courtesy Hermosa Beach Historical Society.)

This view of Hermosa Avenue at Twenty-second Street depicts a bygone era when the intermittently vacant dunes were still windblown and the city had plenty of open spaces. The Pacific Electric Red Car Line divided the northbound and southbound lanes of Hermosa Avenue. (Courtesy Roger Creighton.)

Cousins Don Guild, left, and Larry Gray are depicted in this *Our Gang*–style shot in Hermosa Beach. Guild's parents operated Guild Drugs on Pier Avenue beginning in 1936 and eventually owned 13 drugstores. Guild ran the Antique Guild in the old Helms Bakery in Culver City from 1971 to 1996. Gray, a lawyer who raised four children, was president of the Hermosa Beach Historical Society for three years. The two are still friends and are still living in Hermosa Beach. (Courtesy Guild family.)

This aerial view of Hermosa Beach in the 1920s shows just how industrious a city Hermosa once was. The numbers point out the four factories operating in town at that time: 1) the tile factory, 2) silk mill, 3) glass factory, and 4) chemical plant. Not long after this time, Doak Aircraft was established along Pacific Coast Highway north of Pier Avenue to make plane parts known as "subassemblies." The parts would then be shipped to North American or other airplane plants to become integral parts of aircraft. (Courtesy Hermosa Beach Historical Society.)

This aerial view of the city from water's edge shows oil wells that can be spotted like needle points along the eastern horizon. In the years between world wars in Southern California, petroleum companies were formed, wildcatters fanned out to the coast, drilling rigs and derricks became a part of everyday life, and black crude became a big commodity. Even the "beautiful beach" wasn't immune to the phenomenon. (Courtesy Roger Creighton.)

Looking east from the end of the Hermosa Beach Pier in 1924, this vantage takes in a well-dressed afternoon crowd with the men in boaters and top hats, fishermen along the sides, and the two pagodas that shielded the sun. (Courtesy Hermosa Beach Historical Society.)

Through the Roaring Twenties, the beach in front of the Surf and Sand Club was a vision of summer madness as the umbrellas seemed to number in the thousands all the way up to Manhattan Beach. This shot was taken in 1928. (Courtesy John MacFaden family.)

Hermosa Beach's "Boy Mayor," Logan Cotton, gets down to serious business, making a point of early 1930s beach laws. The sign reads: "Notice to bathers: This is your beach. Help keep it clean. Trunks only, and roll-down suits prohibited. Shoulder straps must be kept in place and no ball playing." A lifeguard is holding the sign, and a bathing beauty—a standard Hermosa Beach photo opportunity—is around for emphasis. (Courtesy Hermosa Beach Historical Society.)

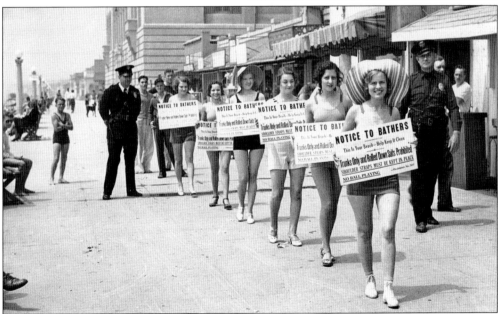

The exposure of flesh, and perhaps too much of it, has been an issue from time to time in Hermosa Beach, and not just because of the modern take on the sun's skin-damaging rays. Overexposure was never more of an issue than in 1935. That's when these ladies, under the watchful eye of Hermosa Beach's finest, protested the antiquated dress code of the previous generation. (Courtesy Hermosa Beach Historical Society.)

During the 1932 Olympic Games in Los Angeles, the Hermosa Biltmore Hotel hosted the athletes from India. This banquet was held in the team's honor in the Biltmore Ballroom, which overlooked the Pacific Ocean. Among those celebrated in the ballroom have been aviator Charles Lindbergh and first lady Eleanor Roosevelt. (Courtesy Hermosa Beach Historical Society.)

The northwest corner of Pier and Hermosa Avenues is depicted in the 1930s. Clothing stores were located in the first two doorways on Pier Avenue. The men's shop on the corner was owned by Ben Aberle. The doorway between stores was eventually opened so that men and women could shop together. (Courtesy Hermosa Beach Historical Society.)

Pictured here in 1932, Clement L. "Flying Bob" Reinbolt, left, liked to be referred to as Hermosa Beach's first resident. He erected the first building at what is now the southwest corner of the Strand and Pier Avenue, somewhere in the present location of Hennessey's Tavern. Reinbolt was named the local superintendent of the Hermosa Beach Land and Water Company in 1909; he held the post into 1910. His widow, Janetta, told historian Pat Gazin that during the week, Hermosa was a ghost town, but on weekends in 1901 and 1902, the area was vividly alive. Reinbolt was called Flying Bob because he had one of the first automobiles in town, a 1913 red Model T, and was fond of the higher speeds. Not only was Reinbolt the first permanent settler in Hermosa Beach, he was also the first city planner, fire chief, baseball captain, and plumber. (Courtesy Hermosa Beach Historical Society.)

Several signs of the times appeared in the 1930s along the north side of Pier Avenue's first block, looking east from the Speedway toward Hermosa Avenue. The Piggly Wiggly Market leased its space at the time from the Kerwin Bakery. A woman in the foreground on this busy corner strolls in apparent defiance of the sign beside her: "Bathers robes to knees on this side of Speedway." (Courtesy Kerwin family.)

This aerial view the original pier shows the amount of undeveloped land in the background east of Pacific Coast Highway. In the years before World War II, much of the inland South Bay was used as poultry farms or truck farms. Many of the vegetable and flower farms were operated by Americans of Japanese descent, who were tragically displaced by the federal World War II–era policy of internment for Asian Americans. (Courtesy Kerwin family.)

The Goodyear blimp drifts over Hermosa Beach Pier, caught in this 1940 photograph looking out Pier Avenue to the ocean. The Los Angeles region's Goodyear blimps are still moored at Carson, about 10 miles inland from Hermosa Beach. Hermosa has always been a favorite destination for Goodyear pilots to bank around for the return trip. (Courtesy Kerwin family.)

The Hermosa Beach Pier head, seen here in 1940, housed the city's library and the chamber of commerce for decades. The Los Angeles County Lifeguards and the Hermosa Beach Surfing Club also had space in the pier head. (Courtesy Hermosa Beach Historical Society.)

This 1947 aerial view shows the sweep of Pier Avenue down the short hill to Hermosa Avenue and toward the pier and surf. Many of the original buildings along both Pier and Hermosa Avenues

are still in use. (Courtesy Hermosa Beach Historical Society.)

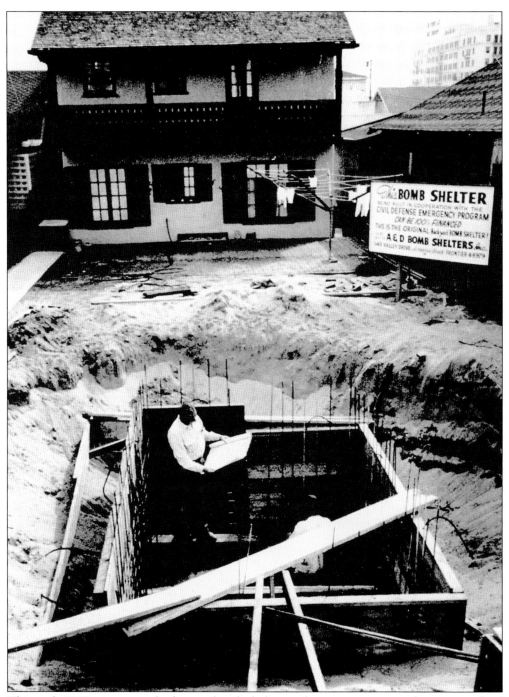

This early-1940s time capsule shows a bomb shelter under construction in the area north of the Biltmore Hotel and east of Hermosa Avenue. It was built with the cooperation of the Civil Defense Emergency Program in reaction to World War II, and not the later Cold War paranoia. Bomb shelters were easier to dig in coastal communities because of the sand, and were constructed beside and under many homes in Hermosa. The fear was that the Japanese would invade Hermosa Beach. (Courtesy Hermosa Beach Historical Society.)

One of the most tragic episodes in Hermosa's history occurred in June 1948, near this spot along Artesia Avenue, a country road used for impromptu drag racing, looking east. Nearby on the southwestern corner of Pacific Coast Highway and Artesia Avenue, the Hi-Spot Drive-In was a busy burger joint (Hotel Hermosa is situated there today). The post-war tradition was for carhop girls to call the local police departments for late-night rides home, if needed. On one particular June night, both Hermosa and Redondo Beach officers showed up to escort two young women home. Only they didn't go home. They ended up in these fields with whiskey and drugs, and their activities included target practice with service revolvers. Redondo Beach Officer Fred Taylor was shot and killed by Hermosa Beach Sgt. Bob McCaulley. Four doctors testified at the trial that McCaulley was under the influence of morphine when the killing occurred. He was convicted of manslaughter and sent to San Quentin. Located in this grassy area today, in the southernmost portion of Manhattan Beach and across Artesia Avenue from Hermosa Beach, are a McDonald's, Kinko's, coffee shop, and other businesses. (Courtesy Bergstrom family.)

Robert "Bergie" Bergstrom, also known as Bob, puts on his best formula-one face. Growing up in Hermosa Beach, "Bergie" was a well-known local surfer, and built the catamaran the *Kahuna*, which was a regular seagoing sight for years along the South Bay shoreline. Bergstrom was general manager of the boatyard in Redondo Beach. (Courtesy Bergstrom family.)

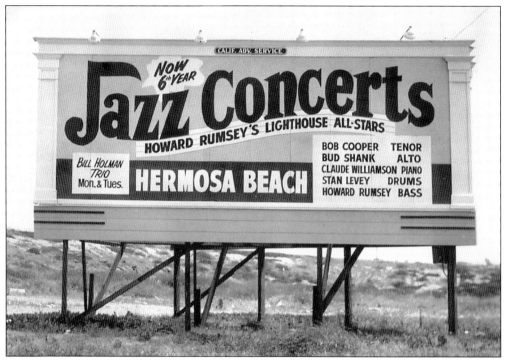

This 1955 billboard on Pacific Coast Highway advertised the joint that became the temple of West Coast jazz. The late, great jazz critic, Leonard Feather, once said, "When you talked West Coast, that's all you talked about: The Lighthouse." Feather also said that the joint's manager, bartender, and bass player—Howard Rumsey—made the venue's reputation. "Howard deserves the credit for the reputation the place had," Feather said. (Courtesy Los Angeles Jazz Institute.)

The Best Food Mart was a Hermosa Beach landmark through the 1950s. Here it's getting a potato chip delivery from another longstanding Southern California business, Laura Scudder's. The Best Food Mart became Mrs. Gooch's for many years, and now houses Star's Antiques. It's adjacent to the Hermosa Beach Fire Department and city hall and catty-corner across Hermosa Avenue from the post office. (Courtesy Hermosa Beach Historical Society.)

Riding on this vintage automobile as it swings in front of the old Fisherman's Wharf at the foot of the Hermosa Beach Pier are legendary musicians in The Lighthouse All-Stars: Shorty Rogers and Jimmy Giuffre with Larry Bunker during 1912 Days in 1952. Cooked up by the chamber of commerce to commemorate the chamber's founding, 1912 Days used to be an annual rollicking good time in Hermosa Beach. (Courtesy Los Angeles Jazz Institute.)

This late-1950s look at 1912 Days shows politicians riding in sports cars that are turning south off Pier Avenue onto Hermosa Avenue. During 1912 Days, businesses throughout the city used 1912 prices on food and drinks, notions, and other commodities. (Courtesy Hermosa Beach Historical Society.)

This is the lunch counter of Gem Cafe in the 500 block of Pier Avenue. Small in size, it was the phone booth of Hermosa restaurants. Here owner Henry Poirer and wife, Grace, are seen with their daughter Chris. Famous for hamburgers and Grace's fresh-baked pies, the Gem Cafe was the favorite place to go for many locals and visitors to the city. (Courtesy Hermosa Beach Historical Society.)

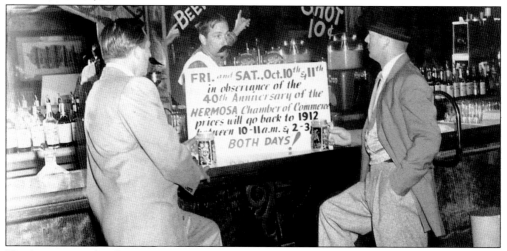

Here's an unusual sight: two guys in a Hermosa Beach bar. But seriously, folks, 1912 Days was an invention of the Hermosa Beach Chamber of Commerce that in the 1950s and 1960s caused some confusion about the date of the 1907 incorporation of the city. The chamber invented 1912 Days to commemorate the inception of the chamber, and local businesses rolled back prices to 1912 equivalents. (Courtesy Los Angeles Jazz Institute.)

Three

BEACH LIFE AND TIMES

It is now time to praise some famous men. There are early surfing greats, and then there are Dewey Weber and LeRoy Grannis. Weber and Grannis epitomized the surfing legends before popular culture glommed onto the sport. They were both unpretentious sportsmen who were always after the perfect wave, yet the imperfect one would also do. And they were Hermosa Beach guys. This photo of Dewey Weber, taken by LeRoy Grannis, shows the master riding the watery wilderness onto Hermosa Beach. Dewey developed the "hot dog style" of surfing after newly designed foam boards afforded him the ability to make quick and tight maneuvers. Generations of surfers have loved this image. Dewey was also the model for the original cartoon character of Buster Brown for Buster Brown shoes—not bad notoriety for a barefoot guy. (Courtesy LeRoy Grannis.)

Every summer, the spacious stretch of beach between the Biltmore Hotel and the north side of the Hermosa Beach Pier has been crowded with tourists soaking in the Hermosa experience. This view of the pavilion at the head of the Hermosa Beach Pier in the early 1930s was taken from Hermosa's first and only high rise building, the Biltmore. (Courtesy Hermosa Beach Historical Society.)

Building a better pyramid in Hermosa Beach meant the kind of enthusiasm shown by these boys. The boys often earned extra money performing acrobatics for visitors to the pier and Strand areas. Standing around, c. 1932, but never loitering, are (kneeling) Jim Kerwin, Darrel "Slasher" Smith, and two unidentified boys; (handstanding and standing) George Herschman, Donnie "Ding" Grannis, Joe Kerwin, Ted Kerwin, and Marian Hebner; (handstanding on top) Fred Kerwin. (Courtesy Kerwin family.)

Bicycling on the Strand in Hermosa Beach has always been a popular activity. This smiling group peddles away on a leisurely 1940s weekend afternoon on a bicycle built for five. (Courtesy Hermosa Beach Historical Society.)

Santa Catalina Island's main harbor of Avalon is more than 40 miles around the horn of the Palos Verdes Peninsula from Hermosa Beach, a tough distance to challenge the more competitive locals to test themselves. Shown here is a 1937 race of aquaplaners as they approach the Hermosa Beach Pier. (Courtesy Hermosa Beach Historical Society.)

Jim Bailey was one of Hermosa Beach's more honored surfers. Rusty, his cocker spaniel, wasn't a bad surfer, either. Both were featured in this classic photograph taken by Doc Ball in 1946, and featured in *Life* Magazine. (Courtesy Schneider family.)

In 1939, Hermosa resident Bunny Seawright won the Women's Division of the Catalina Aquaplaning race. She traveled behind a motorboat while holding a rope tied to the boat and standing on a hardwood board. Shaking her hand is the men's winner, Bob Duntley. His time was one hour, 23 minutes, and 23 seconds; her time was one hour, 50 minutes, and 52 seconds. (Courtesy Seawright family.)

As a large winter wave comes ashore, four surfers peer over the railing at the end of the Hermosa Beach Pier, checking the surfing conditions. Doc Ball took this photo on December 12, 1937. (Photograph by Doc Ball, courtesy Schneider family.)

Back from an early-1940s surfing trip to San Onofre State Beach near Camp Pendleton are a group of Hermosa locals posing at the base of the Hermosa Beach Pier. That was a major trip down Pacific Coast Highway through every city and town along the coast, not an hour and 15 minutes down the San Diego Freeway as it is today. Zucca's, the bar and restaurant that was situated where the Mermaid parking lot is now at Pier Avenue and the Strand, can be seen in the background. (Courtesy Kerwin family.)

The ticket printed for the Hermosa Beach Surfing Club's annual dance in 1940 featured surfers from top to bottom in this photo: John Kerwin, Hal Pearson, Fred Kerwin, Don "Ding" Grannis, and Aaron Wolf at the Hermosa Pier in 1939. The cost per ticket was $1.25, and that included dinner and dancing in the Hermosa Biltmore Ballroom. (Courtesy Kerwin family.)

This beautiful catamaran, under sail just off the coast of Hermosa, was built by hand on the beach at Twenty-first Street by lifelong resident Bob Bergstrom. *Kahuna* was a fixture for years as she became a windy-day alternative for the local surfers. Pushing her through the surf to the open sea, her sails would often be visible sailing along the South Bay coastline. When they were done for the day, Bergstrom and friends would surf her onto shore and pull her along the beach to the Strand wall to await the next windy afternoon. (Courtesy Bergstrom family.)

During the early 1940s, many of these pallapas could be found at intervals along the beach in Hermosa. This one was built at Twenty-first Street. Using the shade from the palms, new mothers would allow their babies to nap quietly to the sounds of the ocean waves. This group also displays musical instruments. To the right, note the hull of *Kahuna*, the Bergstrom's catamaran. (Courtesy Bergstrom family.)

Hermosa Beach motherhood is depicted in 1946 at the Strand wall and Thirty-fifth Street, near the Manhattan Beach border. Pictured, from left to right, are Mebs Skinner with Steve, Ruth Lieb with Andy, Blanca Schneider with Bill, and Dottie Houser with Patricia, Judy, and Art. (Courtesy Schneider family.)

Dottie Droste (Kerwin) rose to the occasion of having photographer Doc Ball's lens trained on her. Ball was a local dentist who indulged in his passions for surfing and photographing others who were likely afflicted. Ball published his photos in *California Surfriders*. Ball snapped this photo of Dottie in 1947 at Hermosa Beach. (Courtesy Kerwin family.)

The Hermosa Beach Surfing Club are pictured on Hermosa Beach in 1939. From left to right, they are Fred Kerwin, Marshall Scherwin, Paul Matthies, Herb Barthell, Ted Kerwin, Jim Bailey, Bob McGowan, John Kerwin, Bill Edgar, Jim Kerwin, Ole Scrivens, Joe Kerwin, Aaron Wolf, and Don Grannis. This image was reproduced approximately 50 years later on a line of sportswear and T-shirts by the company Edgewear. (Courtesy Kerwin family.)

This is the start of the one-mile paddleboard race at the 1940 National Championships held at the Hermosa Beach Pier. Jim Kerwin of the Hermosa Beach Surfing Club won the race. Paddleboard races are still held regularly every summer. (Courtesy Kerwin family.)

This early photo of organized beach volleyball was taken in 1946 at Twenty-third Street. Roy Seawright, who started his own family tournament in the 1960s, is center left in this photograph. Volleyball germinated and grew at Hermosa Beach, spawning increased organization and developing many future pros on the Association of Volleyball Professionals (AVP) annual tour. (Courtesy Seawright family.)

This wide view is a classic summertime photo depicting a panorama of beach activities. It was taken

Tandem body surfing is exhibited by Dottie and Ted Kerwin next to the Hermosa Beach Pier in an outtake from a role shot by John Floria for *Life* Magazine. An article in the July 1948 issue described the Hermosa Beach lifestyle. (Courtesy Kerwin family.)

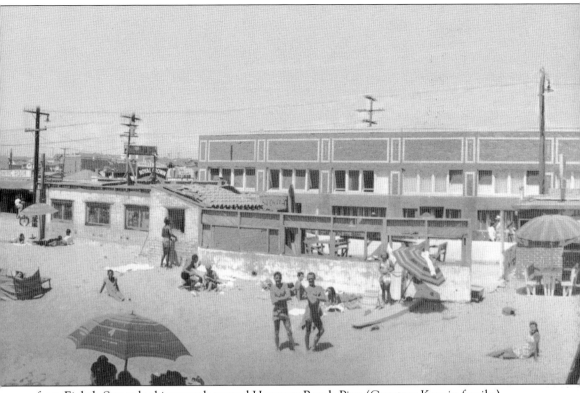

from Eighth Street looking north toward Hermosa Beach Pier. (Courtesy Kerwin family.)

The Hermosa Beach Lifeguards stand on the steps of the pier pavilion in 1947. The importance of physical strength to the guards' job can't be underestimated. These early lifeguards of Hermosa Beach stayed in shape. They have been pulling even the most experienced swimmers out of wild surf and riptides for generations in Hermosa. (Courtesy Kerwin family.)

The Seventeenth Street Seals are shown in 1952. They are, from left to right, Charlie Davis, Mike Bright, John Rhino, Bill Bryson, Chip Post (who became a Hermosa Beach city councilman), Steve Voorhees, Jeff White, Sonny Vardeman (who's honored on Surfers Walk of Fame), and Jimmer Lindsay. (Courtesy Bergstrom family.)

In the halcyon days of surfing, a lot of the guys made their own boards. Greg Noll, nicknamed "The Bull," is seen here in 1950 at age 14 learning the craft that would help make him become one of the central figures in surfing. "Board making was a social deal," Noll wrote. "The word would go out that so-and-so had a chunk of redwood or balsa and everybody would go over to the guy's garage with beer, ya know?" Here the cast of formidable characters includes, from left to right, Noll, Stu Linder, Bergie Bergstrom (on ukulele), Dick Medvie, and John McFarland. Linder won an Academy Award as part of the editing team on John Frankenheimer's *Grand Prix* (1966), and was nominated for Barry Levinson's *Rain Man* (1988). Linder has edited more than 10 films for former El Porto resident Levinson. (Courtesy Bergstrom family.)

Ambition is often something that languishes in Hermosa Beach. But Barnaby was perceived to have had more ambition than most dogs, maybe more than many people in Hermosa. He walked with the mailman. He played with neighborhood kids. He could often be found at the surf line waiting for his master to return from the waves. Here he appears to have a handle on driving. He lived with the Bob Bergstrom family. Up until the 1970s in Hermosa Beach, dogs swam with kids, were allowed on the beach, and ran unleashed throughout the city. (Courtesy Bergstrom family.)

The Twenty-first Street surfers in 1953 are, from left, Beecher Anderson, Bob Bergstrom, Don Peterman, John McFarlane, Penn Post, Stu Linder, Ed Edgar, Ted Bishop, and the four-footed friend, Barnaby. (Courtesy Bergstrom family.)

Shown here in 1952 is the Ocean Aquarium, a popular destination for families and an early predecessor to Marineland of the Pacific, which became a popular tourist destination on Palos Verdes Peninsula. The Ocean Aquarium was situated south of the Hermosa Beach Pier until the mid-1950s. (Courtesy Hermosa Beach Historical Society.)

A trained seal is shown at the Ocean Aquarium before a large afternoon crowd at the Hermosa pier. The man feeding the seal is Darcy McBride, who owned the aquarium with his wife, Maxine. (Courtesy Hermosa Beach Historical Society.)

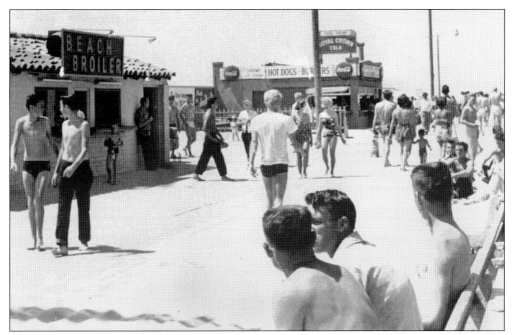

This view of the Strand in the 1960s shows a hot dog stand and the Beach Broiler at the base of Hermosa Beach Pier, the location today of the Los Angeles County Lifeguards headquarters. The restaurant was torn down not long after this photograph was taken to afford a clear view of the ocean. (Courtesy Hermosa Beach Historical Society.)

Bing Copeland is shown surfing an overhead wave in Hermosa Beach in 1963. Copeland learned to surf at age 13 with Greg Noll, and he learned to shape long boards from Dale Velzy. Copeland's "Bing" boards were used by various surfing champions in the 1960s, including Donald Takayama, David Nuuhiwa, and Rolf Arness, the son of *Gunsmoke* actor James Arness. In 1970, Rolf won the World Surfing Championship. As the short board revolution made its way up the coast, Bing Copeland closed his shop and moved the Ketchum, Idaho. (Courtesy LeRoy Grannis.)

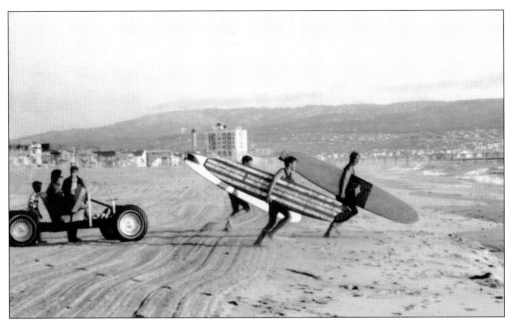

A trio of surfers in the late 1960s is shown about to enjoy an afternoon surf. They are joined by an early predecessor to the Los Angeles County Lifeguard truck. Seen here is Lt. John Horne's dune buggy. He was given special permission to drive on the beach to protect beachgoers as far as the northernmost guard tower—the Neptune Tower on Shakespeare Beach. For reference, note the location of the Biltmore Hotel in the background. (Courtesy Warren Miller.)

The Fourth of July presents Hermosa Beach with the annual opportunity for an epic display of freedom. This early 1960s photo was taken in North Hermosa on the Strand as longtime resident John R. MacFaden lights the fuse on a small cannon before neighborhood children, including Bobby Gilson, Julie Cameron, Margie Gilson, Michael Gilson, Jeff Cameron, Pete Kalionizes, Billy Hopkins, Phil Hastings, Mike Kalionizes, and Nancy MacFaden. Each Independence Day this cannon would signal the start of the children's parade, and then be fired every hour on the hour until 9:00 p.m. (Courtesy MacFaden family.)

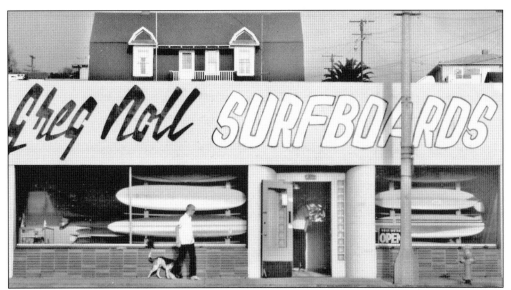

Greg Noll, standing in the doorway, became one of California's most time-honored surfers. He really knew how to make a surfboard and, as this photo attests, how to get the word out to the community. Anyone driving along Pacific Coast Highway in Hermosa couldn't miss the main place to find one of the world's best shaped long boards. (Courtesy LeRoy Grannis.)

This costumed, Mira Costa High School band warms up prior to the annual North End of Hermosa Fourth of July Parade. This early-1960s procession headed south on the Strand during the morning of the Fourth—proud to parade, play, and celebrate Independence Day. All of the kids were awarded prizes and ice cream. (Courtesy MacFaden family.)

This classic photograph from the 1972 Hermosa Beach Open defines volleyball at its best as Buzz Swartz, four feet off the sand, defends the net against all-time volleyball Hall of Famer Ron Von Haggen. These were the days when players started volleying as soon as the sun came up, and quit when the sun went down. (Courtesy Robi Hutas.)

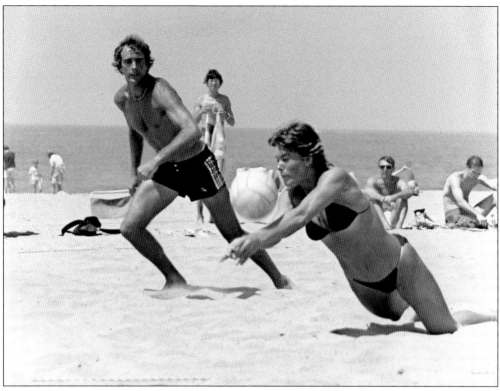

In 1972, Nina Grouwinkel is shown digging a spike as partner Matt Gage looks on in one of the unique aspects of beach volleyball—mixed doubles. These two Hermosa residents were among the most dominant mixed teams on the beach. (Courtesy Robi Hutas.)

This group is shown poised before the beginning of the annual Sixteenth Street Labor Day Tournament, which has surpassed its 50th year. This four-person tourney is one of the most respected tournaments in the area, combining amateurs and professionals alike. On any given weekend, a volleyball tournament of some sort can usually be found somewhere in Hermosa Beach. (Courtesy Robi Hutas.)

No, this isn't the North Shore Pipeline. But this photo of Mike Benavidez on a six-to-eight foot wave at the Hermosa Beach Pier in 1978 says more about Hermosa surfing than words can. (Courtesy Mike Benavidez.)

This 1978 group of local surfers is the Mike Purpus "Hot Lips" Surfing Team at their favorite hangout, Doc's House. Purpus was a seven-time finalist in the U.S. Surfing Championships and was known as one of the West Coast's most progressive and entertaining surfers. From left to right are (kneeling) Tracy Stumble and Steve Martin; (standing) Chris Barella, Monica Lanz, Mike Purpus, Mike Benavidez, Dan Purpus, Liz Benavidez, and Terry Stevens. (Courtesy *Easy Reader.*)

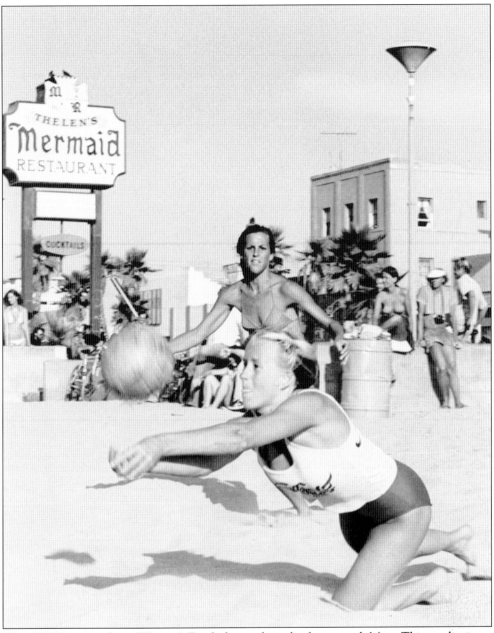

The 1978 Hermosa Open Women's Finals featured, in the foreground, Maya Thiene, digging a pass to partner Linda Robertson. This dynamic duo formed one of the most winning teams of all time. The pair also showed that women could play the sport as ruggedly as the men. The Strand and the Mermaid's sign can be seen in the background. (Courtesy Robi Hutas.)

This enormous crowd at the Hermosa Beach Pier gathered for the 1982 finals of the Hermosa Open. The competing teams featured Tim Hovland and Mike Dodd playing Sinjin Smith and Randy Stoklos. The early 1980s marked a significant period in the upswing of beach volleyball,

particularly in the South Bay's beach cities and especially in Hermosa Beach. Up to this time, beach volleyball was still a bragging-rights competition with little professional prestige. Afterwards, it became a significant pro sport. Stoklos and Smith were victorious. (Courtesy Robi Hutas.)

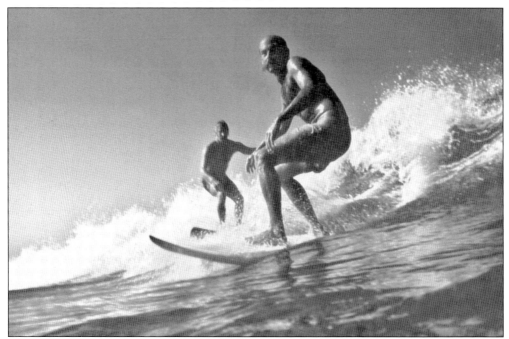

In the foreground of this photograph is Phil Becker, of Becker Surfboards fame, at Twenty-second Street. Besides owning his own surf shop on Pier Avenue for over 30 years, Becker shaped his own boards. He still drives around town in a "woodie." (Courtesy LeRoy Grannis.)

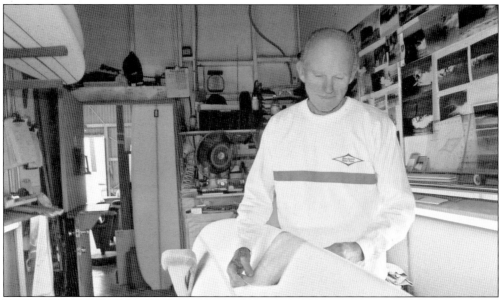

Dudley "Hap" Jacobs moved to Hermosa Beach in 1938, and began shaping surfboards in 1953. Originally partnered with Dale Velzy, Jacobs ventured on own after four years. Jacobs is one of the few remaining surfboard shapers in Hermosa from the era when the city became known throughout the surfing world as the mecca of surfboard shaping—after the introduction of foam boards. Internationally known shapers that made their homes in Hermosa were Bing, Greg Noll, Rick, Dewey Weber, Eddie Talbert, Boyce, Mobley, and Spyder. (Courtesy Chris Miller.)

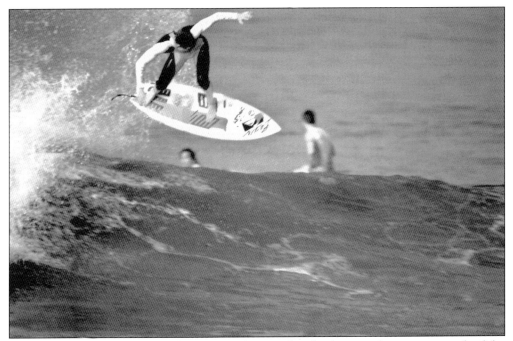

Ty Cukr catches air off Sixteenth Street in Hermosa Beach. At an undersea point north of the Hermosa Beach Pier known as Cable Cars, a big barge loaded with outmoded Pacific Electric Red Cars was sunk after World War II. Beyond the surf line, it created an artificial undersea reef, thus a surf break on stormy days. Lightweight artificial boards allow skilled surfers to make an assortment of acrobatic maneuvers. (Courtesy Mike Balzer.)

The Hermosa Beach surfing scene has been morphing for generations. This 1982 photograph, kneeling from left to right, includes unidentified, unidentified, Mick Barber, unidentified, unidentified, Chance Barber, Steve Howe, Chris Wells, and Mark Kerley; (standing) unidentified, Ronny, Erich "Erich K" Kaufman, Reece Patterson, Jeff Novak, photographer Matt Muir, board shaper Pat Reardon, Todd Balzer (Nicolas Cage's chauffeur), Steve Machin, Scott Johnson, World Surfing Tour regular Kelly Gibson (owner/president, O'Neal Clothing), Wayne Shaw, Paul Loegering, Dave Hollander, Craig Shaw, Todd Jacobs, and World Tour regular Ted Robinson. (Courtesy Mike Balzer.)

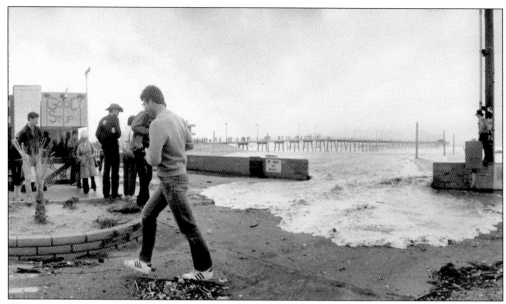

The winter storms of 1983 brought the wild and wonderful Pacific Ocean where no one wanted it: over the beach, through the Strand wall, and into streets, yards, and homes. These shots taken a block north of the Hermosa Beach Pier by longtime resident photographer Robi Hutas illustrate the world's largest body of water appearing that much larger. (Courtesy Robi Hutas.)

The Sand and Strand 5-K Run begins at the Hermosa Beach Pier, goes north on the beach to Longfellow, then returns along the Strand. The event has been held for close to 50 years, and is considered by locals, and runners from elsewhere, a unique, annual tradition that only happens in Hermosa. (Courtesy Chris Miller.)

Annie Seawright wins the women's division of the Sand and Strand Run. The mother of two has won the event several times and has been in the top three of the women's finishers since the 1990s began. One of the finest local runners, Annie Seawright continues the outstanding tradition of female athletes in her family, going back to Bunny Seawright. (Courtesy Chris Miller.)

One of Hermosa Beach's long-lasting annual events has been the International Surf Festival in which lifeguards from up and down the California coast compete for bragging rights and trophies in a variety of events. Here the lifeguards' dory competition pits two-man boat teams against each other at the International Surf festival. Eric Meech and Jason Vance break through a wave at the Hermosa Beach Pier. The Surf Festival has been a midsummer event for six decades. (Courtesy Chris Miller.)

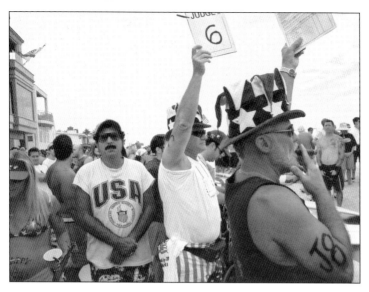

For more than 20 years, at high noon every Fourth of July in Hermosa Beach, the Iron Man of the South Bay competition begins on the beach at Thirtieth Street. Two judges are shown here waiting for participants to return from first leg of the Iron Man, which takes some fortitude and has many detractors, as the caption to the right attests. (Courtesy Chris Miller.)

The Hermosa surfing scene in May 2004 included, from left to right, (standing) Scott Daley, vice president of marketing for Body Glove; D. Levy; Mark Levy, U.S. Surfing amateur champion; Marc Theodore of Theologian Records; Daniel Del Costillo, E. T. manager; Joe Vanjilistie (hidden in back), lead singer of Indisgator; Dennis Jarvis, owner of Spyder Moroccan Blue; Andrew from South Africa; Matt Wells of Body Glove Wetsuits; Roddy Williams, lifeguard; Jared Lange, Becker pro surfer; Eric Nakaji, owner of Ocean Gone Surf Concepts; Holly Beck, pro women's surfer and reality series television star; Ted Robinson, a top-16 world surfer; his son Jordan Robinson;

The winner of the 1997 Iron Man Competition celebrates the final leg of the competition, which, to participants, is sometimes known as the "hollow-leg" leg. The Iron Man consists of a mile run, a mile paddle in the surf, and the ceremonial chugging of a six-pack of beer. A former Hermosa Beach mayor, Bob "Burgie" Benz, got in hot water with locals, newspaper letter writers, and some other officials when he extolled the Iron Man competition while in office. Since the consumption of alcoholic beverages either on the beach or in public streets or on sidewalks is prohibited by law, the Iron Man has always had its rough and rusty downside. It was a tradition designed in a less politically correct era. (Courtesy Chris Miller.)

Tyler Hajzikian, owner of Tyler Surfboards; Greg Browning, pro surfer; Nick Christensen, NSAA national standout; Wayne Shaw, former pro and *Surfing* cover subject; Jim Miller, lifeguard and creator of Power Surfing Experience; unidentified; board-shaper Matt Calvanni; Richard Silva of Body Glove; Eddie Vedder, lead singer of Pearl Jam; Peff Eich; pilot Daryl Dicky; and pro surfer Mike Crowe; (kneeling from left) pro Shaun Burrell; former pro Hagan Kelly; Jamie Meistrell of Body Glove; unidentified; and pro Chris Frohoff; (seated from left) Dane Zaun, Billabong surfer Pat Murphy, and Jim O'Brian, "best local surfer." (Courtesy Mike Balzer.)

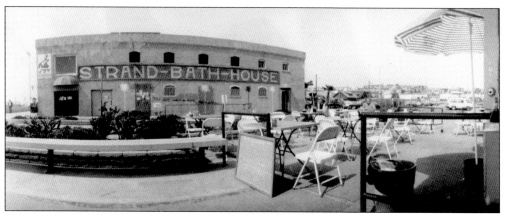

For generations, the Strand Bath House was a Hermosa Beach landmark. This is one of the last photos taken of the structure before it was torn down in the 1990s and replaced with a hotel. (Courtesy Robi Hutas.)

Times change, but there are a few constants in Hermosa Beach—children playing on the swing sets. Sundown on Hermosa Beach is depicted in this photograph by coauthor Chris Miller. The photo won second place overall in an 1999–2000 International Library of Photography Contest celebrating the new millennium. (Courtesy Chris Miller.)

Four

CIVIC AND COMMUNITY ACTIVITIES

Seen in the early 1920s is the Ocean View School bus. Early kindergarten students were transported by this bus to the first location of the school, which was on the site of the St. Cross Church, Monterey at Nineteenth Street. (Courtesy Hermosa Beach Historical Society.)

Getting the Hermosa Beach name known outside the city became an ongoing task for the chamber of commerce. Here in the prestigious Tournament of Roses Parade in Pasadena, the Hermosa Beach School District float travels down Colorado Boulevard on January 1, 1915. (Courtesy Hermosa Beach Historical Society.)

In Hermosa Beach, the boys of summer probably surfed and maybe played volleyball, too. But they also played the national pastime, as this early group of diamonds in the rough provided a little rough on the diamond. John W. Clark, a well-liked mayor of Hermosa Beach, was the namesake for Clark Stadium along Valley Drive north of Eighth Street. The stadium was actually a state-of-the-art minor league emporium when it was dedicated in 1937. Semi-pro games were played in the stadium and minor league teams trained here for 25 years, or until the Brooklyn Dodgers moved to Los Angeles in 1959. (Courtesy Hermosa Beach Historical Society.)

The 1916 all-volunteer Hermosa Beach Fire Department is posed with their truck. The fire department was originally situated on Hermosa Avenue just south of Pier Avenue. (Courtesy Hermosa Beach Historical Society.)

The early Hermosa Beach Police Department—eight strong—were depicted here in the 1930s with two unidentified citizens at the Hermosa Avenue police station. The jail cells had no ceilings, and passersby could approach the cells from the street to talk through bars to the prisoners. (Courtesy Hermosa Beach Historical Society.)

Biltmore Hotel interior is shown during a 1928 Hermosa Beach Chamber of Commerce luncheon. Among the local dignitaries seated at the banquet table in the ballroom are Ralph and Charlotte "Lottie" Matteson. (Courtesy Hermosa Beach Historical Society.)

On the steps of the Hermosa Pavilion in 1925 is the Hermosa Youth Community Band. Complete with their uniforms, the young people played for visitors to the Municipal Pier during the 1912 Days celebrations. The band also marched in parades, and played for Christmas concerts and at functions in the Hermosa Biltmore. (Courtesy Hermosa Beach Historical Society.)

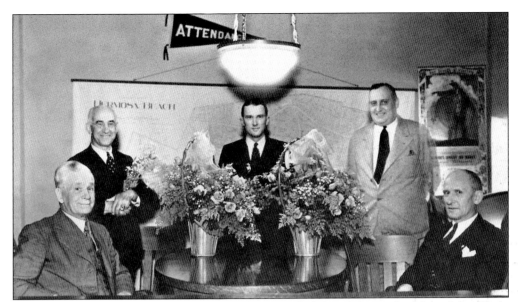

The 1930–1932 Hermosa Beach City Council consisted of, from left to right, Mayor John Clark, Doc Lindsay, Logan Cotton (known as the "Boy Mayor" later on), Glade White, and George Learned. The Learned family owned the local lumberyard, which has been a regionally notable business for decades. Clark was an Englishman whose interest in Clark Stadium was to use the area for lawn bowling, which has survived through the years as a sport played primarily in white clothing by both men and women. (Courtesy Hermosa Beach Historical Society.)

Angels, elves, and Santas pose with teachers from Prospect Heights School, which was originally on a hilltop overlooking the city on Prospect Avenue. The site is now the location of Fort Lotsa Fun, one block from Our Lady of Guadalupe Roman Catholic Church and School. (Courtesy Hermosa Beach Historical Society.)

Students are gathered on the steps of North School in 1937. In the 1930s and 1940s, Hermosa had five grammar schools and a junior high school. The grammar schools were South, North, Hermosa View, Hermosa Valley, and Prospect Heights. The very classically structured Art Deco building of the Hermosa Beach Community Center at Pier Avenue and Pacific Coast Highway was formerly the junior high. For the first 50 years of its existence, the Hermosa Beach School District welcomed about 2,500 students annually. Close to 70 years after this photograph was taken, at least seven of the students still lived in Hermosa Beach, including Don Guild, Larry Gray, Bill Varney, Parker Kemp, Edgar "Fuzz" Nash, Frank Sasine, and Stanley Dunn. (Courtesy Larry Gray.)

In 1935, the Hermosa Beach Fire Department posed for this photograph. The HBFD quelled many a blaze through Hermosa county, and many citizens owe their lives and property to the department. (Courtesy Hermosa Beach Historical Society.)

The Sandpiper Club founders are seen here during a 1935 conclave. The Sandpipers, who hailed from several beach cities, were founded in 1931 to help families in need in the community during the Great Depression years. In their first year of existence, they gave out 19 Christmas baskets. Last year, the Sandpipers gave out hundreds of baskets to needy families. These five women, among the original seven founders, from left to right, are Alice Folay Yarish, Mary Mathews Wilke, Blanche Hazzard, Ann Cox, and Margaret Kemp. (Courtesy *The Beach Reporter.*)

Pier Avenue School was rebuilt in 1939 after the 1933 Long Beach earthquake, with state-of-the-art, poured-in-place concrete construction—a product of the Works Progess Administration, a Depression-era federal agency. Over the entrance doors, six-foot-tall letters spell out, "Where there is no vision, the people perish." The school has 18 classrooms, a gymnasium, four tennis courts, a 500-seat auditorium, and recently added a skate park. It's a block from Clark Stadium, basketball courts, and the Hermosa branch of the Los Angeles County Public Library. Unfortunately, the school was closed in 1979 due to declining enrollment and is currently being used as a community center. (Courtesy Chris Miller.)

On August 23, 1930, this statewide Kiwanis Club Conference was photographed in Hermosa Beach. The Kiwanis have always had a very visible and active role in Hermosa with their Christmas.

Throughout the 20th century, the Hermosa Beach Women's Club was responsible for various social activities and events, including an annual breakfast and participating in the St. Patrick's Day Parade. The 1946 Women's Club, from left to right, included (sitting) Agnes Anderson, Grace Moll, unidentified, Flela Williams, Virginia Williams; (standing) Ava McKenzie, Mrs. Byron C. Hibbetts, Dora Traphagen, Lillian Wilkinson, Edith Narcross, and Anna Freese. (Courtesy Hermosa Beach Women's Club.)

tree lot, Builders Club for young people, and scholarships. The Kiwanis were involved in the construction of Plaza Clock Tower in downtown Hermosa. (Courtesy Kiwanis Club.)

The Les Bacon and Sons Thunderbird Car Club takes over the Bacon Ford Franchise lot at Aviation Boulevard and Pacific Coast Highway (now Ralph's Market). The Ford Motor Company introduced the T-bird in 1955 and the luxury sports car became an immediate automotive icon. A membership in the Bacon T-bird Club got the owner and his family membership in the spa, pool, and gym behind the lot in the Bacon family compound. Les Bacon once sponsored 12 Little League teams. (Courtesy Bacon family.)

In 1935, Mayor John Clark used $3,500 of his own money to purchase a parcel of land on Valley Drive south of Pier Avenue. With the help of WPA funds, he built Hermosa Beach's own lawn bowling facility modeled after greens he had seen in his homeland of England. For his vision and commitment to the community, the sporting facility, Clark Stadium, was named in his honor. In this March 1959 photograph, Jack Jones, then 84, shows Donna Berry the finer points of lawn bowling. The club is still very active; participants are encouraged to wear all white garb. (Courtesy Hermosa Beach Lawn Bowling Club.)

The 1961 pennant winners of the Coast Lawn Bowling League were the Hermosa Beach Tigers. From left to right, they were (first row) Joe Holland, Jack Wagstaff, Bob Hedley, and M. Pinous; (second row) Jack Jones, M. Baldwin, Anne Hood, Oscar Kjellgren, Alice Ehlers, and Cathy Hamilton; (third row) Whitey Lampella, Red Wright, M. Baldwin, Bill Todd, H. Brooks, and W. Barlow. (Courtesy Hermosa Beach Lawn Bowling Club.)

The official seal of the City of Hermosa Beach was created by graphic designer John T. Hales, and adopted by the city in September 1965. Hales is shown above painstakingly piecing the seal together with his son Donald and wife, Lorraine. The seal's ingredients included 3,000 pieces of Italian tile with beach pebbles and shells. Showing his gratitude for the city is Mayor Quentin "Boots" Thelen, below. Thelen is the owner/proprietor of The Mermaid, the restaurant and bar that exists on the Strand just north of Hermosa pier. (Courtesy John T. Hales.)

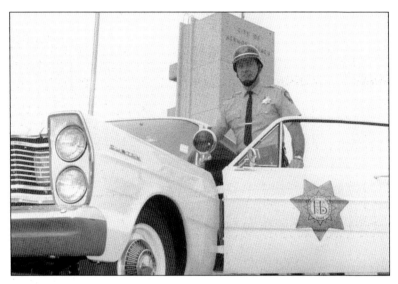

In 1965, the city seal was officially affixed to the Hermosa Beach Police Department squad cars. Here Officer Richard Hibbar demonstrates a readiness to protect and serve the residents. He is parked in front of the recently constructed city hall of Hermosa Beach. (Courtesy John T. Hales.)

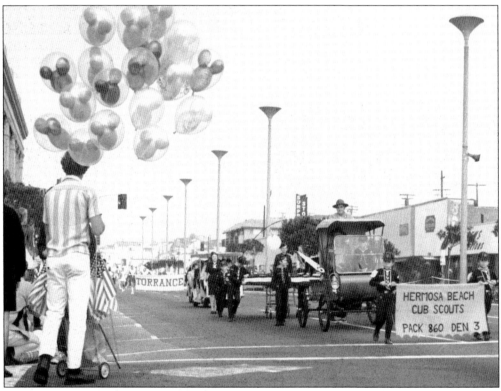

Hermosa Avenue has been the route of many parades. This early 1960s image depicts a Hermosa Beach Cub Scout troop as it made its way south toward Pier Avenue. Other parades used this route, including the annual 1912 Days Parade and the well-attended Pet Parade, which one year was honored by grand marshal Roy Rogers riding Trigger down Hermosa Avenue followed by 800 children, hamsters, goats, and other beloved four footed animals. (Courtesy Hermosa Beach Historical Society.)

At Pier Avenue School in 1970, the curriculum for junior high students included homemaking for the girls, shop for the boys, tennis, human relations, band, and choir as well as academics. Learning to knit from homemaking instructor Jackie O'Mara are eighth graders Michelle Michenovich, Stephanie Atkins, Julie Simmons, Lynn Moore, Erika Ginn, Jennifer Armer, Terri Peck, and Suzette Fitzgerald. (Courtesy Connie Roderick.)

The Hermosa Beach Women's Club celebrated its 80th anniversary in 2004 with the theme, "The Roaring Twenties." From left to right, they are Thelma Greenwald, owner of the Sea Sprite; Emmie Schillhahn, Pat Love, Jean Cullen, city clerk Elaine Dorfling, Carol Shakely, Jean Lombardo, and Diane Miller. (Courtesy the Women's Club.)

In 2004, Hermosa Beach celebrated its 100th year as a school district, and this poster was created to honor that milestone. The top image was taken in 1921 at the original Pier Avenue School at Pier Avenue and Pacific Coast Highway. The lower image was taken by photographer John Post

and directed by Chris Miller in early May 2004 of the entire student population of the Hermosa Beach School District. They were there to attend a David Benoit concert in the auditorium in honor of the centennial. (Courtesy Ron Romero.)

The "Sister City" program was initiated in Hermosa Beach in 1974 by Joe Diaz and Jack Belasco. Hermosa's southerly "sister" is Loreto in Baja California, Mexico. To this day, the relationship has grown and continues to be well supported citywide. Loreto is a large fishing village that was the site of the first Catholic mission in California. An exchange program between junior high students is still conducted. This photo was taken in Loreto on a trip honoring Hermosa Beach's 90th birthday and Loreto's 300th. Hermosa residents brought presents including school and medical supplies and an ambulance. (Courtesy Hermosa Beach Historical Society.)

In 2002, Hermosa Beach philanthropists David and Margaret Schumacher gave $1 million toward the new construction on the Hermosa Beach Pier in honor of David's twin brother, Paul. The new pier head was dedicated in the summer of 2005. (Courtesy Chris Miller.)

Five

ENTERTAINMENT
AND HOLLYWOOD

The formidable lineup of The Lighthouse All-Stars is advertised in 1955 on the front of one of the most legendary nightclubs in Los Angeles area history, The Lighthouse. A familiar surfer's conveyance, a "woodie," is parked at the left. The greatest jazz players, from Miles Davis and Dizzy Gillespie to Ornette Coleman and Gerry Mulligan—and greatest surfers—drifted in and out of Hermosa Beach for over 50 years. (Courtesy Hermosa Beach Historical Society.)

The Seawrights, Roy and Bunny, are seen in silhouette on the beach in 1924. Roy W. Seawright was a special effects technician for the movies. Bunny was one of the top female water-sports athletes of her day. Roy's special effects work can be seen in such Laurel and Hardy films as *Babes in Toyland* (1934), *Way Out West* (1937), and *Saps at Sea* (1940), as well as other films like *Topper* (1937) with Cary Grant, *Captain Caution* (1940) with Victor Mature, and *The Big Cat* (1949) with Lon McCallister. For three years in a row, Seawright was nominated for an Academy Award for Best Effects, Special Effects in the following movies: *Topper Takes a Trip* (1939), *One Million Years B.C.* (1940), and *Topper Returns* (1941). The Seawrights made their home at 2627 The Strand for more than 60 years. (Courtesy Seawright family.)

Judge W. S. Herbert lived in this house, built before 1915 and still in use, at 2024 Circle Drive. William Jennings Bryan lived in it for a time. Other Hermosa society figures included Judge Curtis Wilbur, the Chief Justice of the California Supreme Court from 1922 to 1924 and Secretary of the Navy from 1924 to 1929. Hermosa Beach society through the years included the Chandlers, who owned the *Los Angeles Times* for generations, and resided at 2909 The Strand. Evangelist Aimee Semple McPherson, who inspired Sinclair Lewis to write *Elmer Gantry*, visited her mother, Ma Kennedy, in Hermosa Beach often at 2002 Rhodes Street. "Pinky" Snyder, one of the last 19th-century mayors of Los Angeles, lived at 2020 The Strand. (Courtesy Chris Miller.)

William Jennings Bryan loved Hermosa Beach and returned whenever he was in the Los Angeles area. A Nevada congressman born in Illinois, Bryan made three unsuccessful runs for the U.S. presidency on the Democratic ticket—in 1896, 1900, and 1908. He served as Secretary of State under Pres. Woodrow Wilson. When he resigned that post in 1918, he made a six-week sojourn to the Berth Hotel in Hermosa. Known as the Great Commoner, Bryan championed liberal causes, including women's rights, income tax, prohibition, and labor laws. William Jennings Bryan Jr., whose law practice was in Los Angeles, resided at 236 Tenth Street in Hermosa Beach. (Courtesy Hermosa Beach Historical Society.)

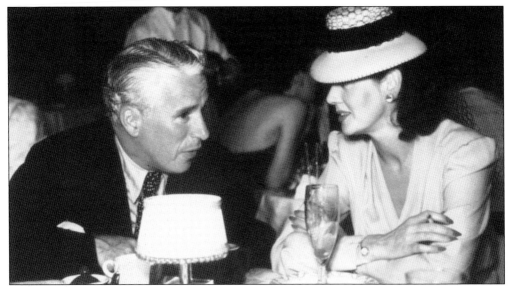

The gentleman on the left was Charles Spencer Chaplin, whose summer home was located at 32 Tenth Street in Hermosa Beach. Charlie Chaplin's lasting greatness as a filmmaker, and his iconic character of the Little Tramp, have lived on celluloid across generations, across the world. Chaplin kept a low profile in Hermosa. So did Clark Gable and Carole Lombard, who spent their honeymoon at 4 The Strand, Hermosa Beach.

Mae Marsh wed newspaperman Louis Lee Arms in 1918, and the pair resided for decades at 2340 The Strand in Hermosa Beach. Marsh, a former convent girl, was immortalized by D. W. Griffith as the star of the great director's most enduring masterpieces, *The Birth of a Nation* (1915) and *Intolerance* (1916). She exuded similar qualities to Griffith's other great silent star, Lillian Gish; both were able to portray youthfulness yet maturity, frailty yet spiritual strength.

George J. "Slim" Summerville was a familiar face in Hermosa Beach and everywhere else. That's because he was one of the most ubiquitous character actors of Hollywood's first half century, playing one of the most recognizable Keystone Cops in the silent era, and many a rustic character thereafter. He also directed many silent films. Billed as Slim Summerville, his sound films as an actor included *All Quiet on the Western Front* (1930), *White Fang* (1936), *Rebecca of Sunnybrook Farm* (1938), *Jesse James* (1939), and *Tobacco Road* (1941). He lived at 1820 The Strand. Many Hollywood figures lived in Hermosa from time to time, including character actor Murvyn Vye and *All in the Family* director/producer John Rich.

John "Doc" Ball, seen here in 1935, was a local dentist. He fixed many a tooth, but he also rode many a wave. More than that, he photographed surfers and the surfing lifestyle, of which he was a part, and wrote, produced, and privately published, in 1946, what became the surfers' book of Genesis—*California Surfriders: A Scrapbook of Surfriding and Beach Stuff.* This was heady stuff indeed: 166 photographs on 103 pages. All the photographs were taken by Doc with a Graflex in a watertight case he called his water box, up and down the Pacific coastline. Doc began his photograph odyssey using a Kodak Autographic folding camera. His photographs appeared in *Life, Look, Popular Mechanics,* and other magazines. The chapter "Big Days at Hermosa Beach" in *California Surfriders* runs 20 pages. Only 510 copies were ever printed. (Courtesy Bank Wright.)

The sweet sounds of Lighthouse jazz issue from the trumpet of Shorty Rogers and the bass of Howard Rumsey. Shelley Manne, who owned the nightspot Shelley's Manne Hole in Los Angeles, is seen on the drums in the background. There were nine Lighthouse All-Stars albums recorded between 1952 and 1956 and featured the likes of Bud Shank, Conte Candoli, Rolf Ericson, Maynard Ferguson, Hampton Hawes, Frank Patchen, Russ Freeman, Claude Williamson, Stu Williamson, Sonny Clarke, Lennie Niehaus, Richie Kamuca, Red Mitchell, Barney Kessel, and others. (Courtesy Los Angeles Jazz Institute.)

Howard Rumsey's Lighthouse All-Stars jam amid the heyday of The Lighthouse. These particular cats, from left to right, are (first row) Frank Rosolini on trombone, Richie Kamuca on sax, and the venerable Bob Cooper, also on sax; (second row) Stan Levey on drums, Howard Rumsey on bass, and Victor Feldman tinkling the ivories. (Courtesy Los Angeles Jazz Institute.)

Howard Rumsey and a shaggy friend pose at the entrance to The Lighthouse. "Howard Rumsey loved Hermosa Beach," reads a 1986 story in the Torrance *Daily Breeze*. "From the first time he swung down Pier Avenue into its sun-blinded environs to play at the Hut Ballroom in 1937, he thought of living there. Later, he used to hang out at Zucca's, and was a regular for 1912 Days." Lighthouse owner John Levine took over 30 Pier Avenue in 1949, taught Rumsey the liquor business, and installed the bass player as manager. Rumsey had tired of the road, crisscrossing the country as the bass player with Stan Kenton's big band. Rumsey found a home base at The Lighthouse. The Hut was a popular 1920s and 1930s outdoor dance pavilion at Eleventh Street and the Strand. (Courtesy Stan Levey and Los Angeles Jazz Institute.)

This 1954 snapshot captures a raft of luminaries in front of Howard Rumsey's Lighthouse. Third from the left, beside Miss Hermosa, is Stan Kenton, one of jazz's greatest bandleaders. Rumsey had played bass in Kenton's band for years. Second from the right is Bobby Troupe, who wrote and performed "(Get Your Kicks on) Route 66," and costarred with his wife, Julie London, on NBC's *Emergency*, a long-running show produced by London's ex-husband, Jack Webb. (Courtesy Los Angeles Jazz Institute.)

Greeting Miss Hermosa for the Hermosa Beach Chamber of Commerce's 1912 Days in front of The Lighthouse is Gene Norman, a Los Angeles radio disc jockey and TV personality who owned the Crescendo Club on Sunset Boulevard. (Courtesy Stan Levey and Los Angeles Jazz Institute.)

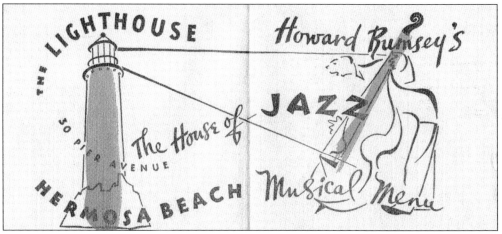

Duplicates of this memento of The Lighthouse, located at 30 Pier Avenue, sopped up the condensation from a million beers and cocktails through the years, while sounds wafted through the joint from the instruments of Miles Davis, Dizzy Gillespie, Art Blakey, Gene Krupa, Gerry Mulligan, Max Roach, Charles Mingus, Ornette Coleman, Shelley Manne, Chet Baker, Shorty Rogers, Louis Bellson, Stan Getz, Ramsey Lewis, Oscar Peterson, Herbie Mann, Cal Tjader, Horace Silver, and Red Norvo. Rumsey often said that bringing Max Roach into the fold helped bring jazz's general marquee to Hermosa Beach. "They all wanted to play with Max or listen and watch," Rumsey said. (Courtesy Los Angeles Jazz Institute.)

The words "Carefree Frolic" epitomized the Hermosa Beach mystique to many visitors and residents alike. Saxophonist Bob Cooper and bass player Howard Rumsey, far right, broke out some subtle threads at The Lighthouse to demonstrate just how carefree they were. Cheesecake was a part of the show, the times, and Hermosa Beach. The Lighthouse drew national attention to Hermosa Beach when NBC's Dave Garroway hosted a report from the club on the Sunday show *Wide Wide World*. (Courtesy Los Angeles Jazz Institute.)

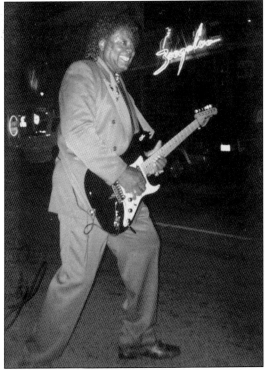

Guitar Shorty takes to the streets of Hermosa Beach. He's a regular at Cafe Boogaloo on Hermosa Avenue. The cafe is located in the old Hermosa Beach Post Office. Shorty, known officially as David Kearney, was born in Houston and raised in Kissimmee, Florida. He played in the Ray Charles Band at 16, recorded with Willie Dixon at 17, found a regular gig with Guitar Slim in New Orleans, and married a lovely woman named Marcia. Her brother was fascinated by the playing of the new family addition. This brother-in-law was Jimi Hendrix, who could play a little guitar, too, and was said to have learned the art of playing from Shorty. Shorty's been a Los Angeles area player since 1971. (Courtesy Chris Miller.)

Ozzie and Harriet Nelson are seen here up to no-good in this rare photograph. No evidence exists that the phony currency they're printing was passed in establishments in their adopted summer home in Hermosa Beach. The corrupting influence on these squeaky-clean icons of 1950s America appears to be "Red" Skelton (right). The Nelsons lived in North Hermosa at 3133 The Strand. *The Adventures of Ozzie and Harriet* ran on ABC from 1952 to 1966.

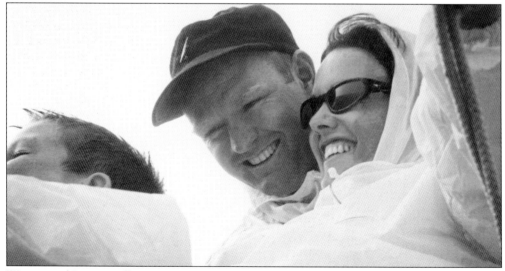

Warren and Dottie Miller are pictured c. 1965 with son Scott, left. Warren Miller Films, based on Pier Avenue in Hermosa Beach, made documentaries about surfing, skiing, snowboarding, and other sports and were direct precursors to the rise of extreme sports. Miller's more than 50 feature-length films include *Skiing a la Carte* (1978) and *Endless Winter* (1995). Known as the "king of sports movie makers," Miller was once described in the *Los Angeles Times* as a "combination of Jean-Claude Killy, Robert Redford, Ingmar Bergman, and Woody Allen." The Millers lived at 3417 The Strand in Hermosa Beach. (Courtesy Miller family.)

LeRoy Grannis wasn't only a world-class surfer, but also a world-class surfing photographer. Here he shows off his steady shooting skills at Hermosa Beach. Grannis began surfing in 1931, and was a charter member of the Palos Verdes Surfing Club in 1935. Grannis was cofounder of *Surfing Magazine*, and was head photographer of *Surfing Illustrated* until he retired in 1971. He was featured in *Life Magazine* in 1990, and inducted into the Surfing Hall of Fame in 1991. Doc Ball took this photograph. (Courtesy John Grannis.)

Leonard Wibberley, the author whose novel *The Mouse That Roared* was made into a popular 1959 movie starring Peter Sellers, lived the last half of his life in Hermosa Beach. Wibberley had been a globe-trotter, his son, "Coco," (also known as Cormac) told the Hermosa-based web site The Aesthetic, "but when he came to Hermosa, he said he couldn't find a better place to live." Wibberley, who occasionally wrote under the name Patrick O'Connor, was a columnist for the Torrance *Daily Breeze*, and wrote biblical and historical books, at least four of them novels based on the life of Thomas Jefferson. Wibberley died in 1983. The second Wibberley generation of writers, Cormac and Marianne Wibberley, are screenwriters whose credits include *Charlie's Angels: Full Throttle* (2003), *National Treasure* (2004), and *The Shaggy Dog* (2005), among others. As for other literary lights and Hermosa, John Steinbeck wrote portions of *To a God Unknown* here, and poet Robinson Jeffers (*Tamar*) and novelist Thomas Pynchon (*The Crying of Lot 49*) also lived for periods of time in the city. Raymond Chandler (*The Big Sleep*) also frequented Hermosa haunts. (Courtesy Cormac Wibberley.)

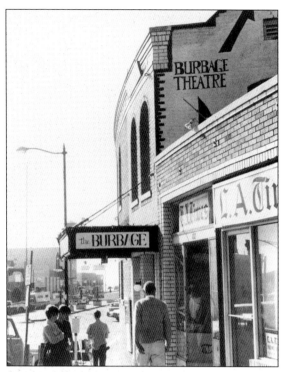

The Burbage Theatre, which hosted stage productions, concerts, and local musicians, was located on Pier Avenue in the 1970s. Other venues that drew the arts faithful included the 1950s beatnik hangout, Insomniac Cafe, and the Bijou Theatre, which hosted *The Rocky Horror Picture Show* every weekend for more than 10 years. (Courtesy Hermosa Beach Historical Society.)

Mike Lacey has operated the Comedy and Magic Club in Hermosa Beach for more than a generation. Jay Leno, above with Lacey, has been coming back to the Comedy and Magic Club on Sunday nights to hone his act and stay facile in case the road claims him back from his current gig as the established heir to Johnny Carson on *The Tonight Show.* You name them, they all played and still play the Comedy and Magic Club: Robin Williams, Garry Shandling, Jerry Seinfeld, Chris Rock, Billy Crystal, David Steinberg, David Brenner, et al. And Lacey has always maintained an abiding interest in magicians, who have consistently played the venue for more than 20 years. (Courtesy Chris Miller.)

David Benoit grew up in Hermosa Beach and has performed contemporary jazz in many of its venues. He also played for many years at the former Manhattan Bar and Grill in Manhattan Beach. The pianist, composer, and conductor is a five-time Grammy Award nominee and classical music artist. He has performed four times at Carnegie Hall, once with Leonard Bernstein, and on the steps of the Capitol Building in Washington, D.C. Benoit has performed with Kenny Loggins, Faith Hill, David Sanborn, and many other artists. He lives on Palos Verdes Peninsula. (Courtesy Chris Miller.)

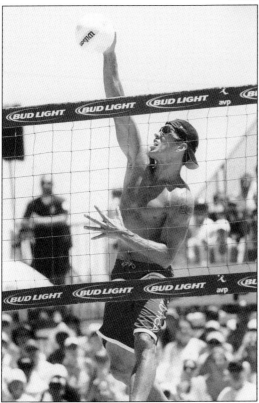

Eric Fonoimoana of Hermosa Beach had a very good day on September 26, 2000, in Sydney, Australia. He and partner Dain Blanton climbed the medal podium at the Olympic Games to receive gold medals for the United States in the two-man beach volleyball competition. The duo defeated a Brazilian tandem to take home the gold. "Fonoi" was born in Torrance, raised in Hermosa Beach, attended Mira Costa High School in Manhattan Beach, and California State University, Santa Barbara. Other Olympians who have called Hermosa Beach home include Micki King, a 1972 gold medalist in the springboard, and Charles Paddock, who won gold in the 100 meters and as a member of the 400-meter relay team in the 1920 Olympic Games in Antwerp, Belgium. Paddock was portrayed competing in the 1924 Paris games by Dennis Christopher in the Academy Award–winning Best Picture, *Chariots of Fire* (1981). (Courtesy Daryl Holter.)

109

Pennywise is one of the local Hermosa Beach–based alternative (punk) bands that has left a large mark on popular music. They are, from left to right, Fletcher Dragge, Jim Lindberg, Byron McMakin, and Jason Thirsk. Randy Bradbury later joined the band. Pennywise has gone on to play international venues, including the Olympic Games in Salt Lake City. Punk music has been well-represented in Hermosa Beach by the Circle Jerks, Black Flag, and the Descendents (Courtesy Kevin Williams.)

Concerts on the Beach became a regular Hermosa Beach feature on Sunday nights in the 21st century. Here Venice plays the beach. Other groups who have entertained the locals and tourists alike have been Dick Dale and the Coasters. (Courtesy Chris Miller.)

Six

Late 20th and the New Century

The Either/Or Bookstore, which used to dominate several storefronts along the upper edge of the northeastward curve of Pier Avenue, as seen from Hermosa Avenue, was something akin to the Southern California version of San Francisco's City Lights Bookstore. The inside was a rambling affair, with nooks and crannies, short staircases, bookcases everywhere, and several imperiously tolerant cats. The selection was eclectic, the mood music occasionally esoteric, and the book-browsing experience often enlightening. (Courtesy Hermosa Beach Historical Society.)

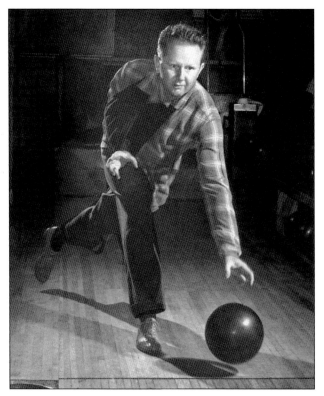

Leonard Liston owned and operated Hermosa Bowl, which was located for decades where Hennessey's Tavern abuts the Strand. Hermosa Bowl had 10 lanes and was a premiere local draw until the postwar years when a new alley was installed near where Hope Chapel is located and included an automatic pin-setting device. Liston lost the use of one arm in World War II. (Courtesy Daryl Liston.)

The Bacon family Ford is seen here in 1954, the year Les Bacon took over the dealership at Aviation Boulevard and Pacific Coast Highway in Hermosa Beach. Roger Bacon is seen behind the wheel, Les Bacon is in the middle, and Roger's brother, Robert, is on the right. In the backseat are Marion with Robert's son, Bruce, and the family four-paws, Lady Lindy and Rusty. In 1977, the shopping center replaced the car lot. (Courtesy Bacon family.)

This 1956 Ford parked near the Strand on Twenty-second Street was the typical mode of transportation for the local surfer. It could accommodate his surfboard, maybe a few friends, and their boards, too. (Courtesy Hermosa Beach Historical Society.)

The Strand has seen a multitude of uses over the years. Here Bob, Linda, and Bill Schneider go for a ride on a Strand cruiser in 1946. Bicycling on the Strand was originally against the law, but Strand cruisers became the method of getting around the city and the South Bay. Their rental became a regular business, and for many Hermosans and visitors a weekend ritual. (Courtesy Hermosa Beach Historical Society.)

The Hermosa Beach Pier, seen here c. 1960, was a favorite spot for South Bay fisherman for nearly a century. This version of the pier stood for more than 30 years and was replaced in 1965. (Courtesy Hermosa Beach Police Department.)

When the Biltmore Hotel was torn down, it marked the end of an era in Hermosa Beach. The huge and formerly luxurious building was built as the Surf and Sand Club in the 1920s and had hosted Washington and other dignitaries and Hollywood stars. Even aviator Charles Lindbergh was feted in the ballroom. Eleanor Roosevelt took it over for a time to promote charitable causes in the 1940s. Mobster Bugsy Siegel tried to buy it. The International Vangelica Society acquired it in 1966, then the Cup of Cold Water Ministry, which operated it as a mission. "Hippies and vagrants" and drifters found temporary shelter inside it, according to news reports, then several fires had to be extinguished there. It was torn down in 1969. The building had lived its storied history. (Courtesy Hermosa Beach Historical Society.)

The running board of this vintage Model A Ford works well for snapshots of the kids, possibly during the chamber of commerce's annual 1912 Days. The annual celebration brought dozens of old-time autos into town to fete a bygone era. This young girl shown in the early 1960s happens to be coauthor Chris Ann Miller. (Courtesy Warren Miller.)

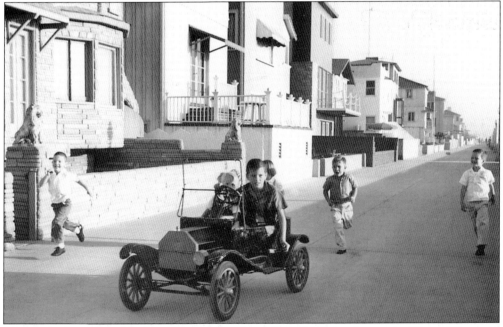

Some kids along the upper Strand, including driver Scott Miller and passenger Kurt Miller, used to climb into this gasoline-powered, one-third-sized replica and buzz around the neighborhood until the noise was too much for some folks. The replica was eventually donated to the Boys Club of America. (Courtesy Warren Miller.)

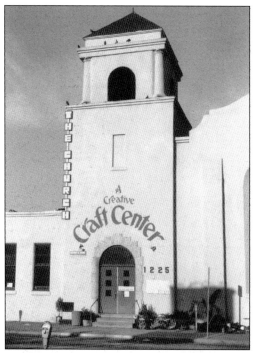

The parking lot at Manhattan Avenue and Fourteenth Street was originally a Baptist house of worship that was converted into a crafts center known as "The Colony" in the early 1970s. Local artists who used it as a base of operations ranged from stained glass and candle makers to tie-died shirt dealers. The building also held the offices of the punk rock band Black Flag. (Courtesy Hermosa Beach Historical Society.)

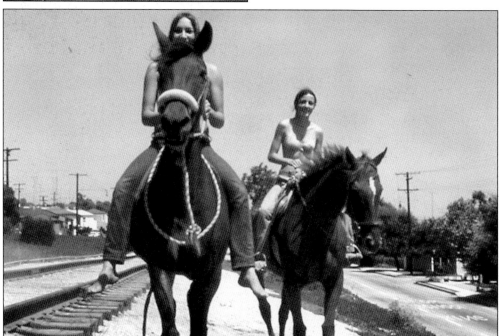

Hermosans and visitors had to adjust to the rules and regulations of regular society, but generally did so later than others in surrounding cities. In more carefree days, horse riders coming from stables up on Rosecrans Avenue or from Playa del Rey could canter along the shoreline down past the Redondo Beach Pier. In this image, riders are seen along the old Santa Fe Railway tracks in the strip of parkland known today as the Greenbelt. (Courtesy Hermosa Beach Police Department.)

Carol Tanner is shown here in the 1970s with her sons, Scott and Don Funk. Tanner has been a library aide of the Los Angeles County Public Library, Hermosa Beach Branch, for decades. Scott, top, was an owner/operator of Tavarua, the heart-shaped Fiji Islands cay that became a surfing paradise featuring awesome waves at the spot known as Cloudbreak. *Surfing Magazine* featured Cloudbreak in 1989 as having one of the best wave breaks worldwide. Don, a musician, lives with his wife and two children in Newport Beach. (Courtesy Tanner family.)

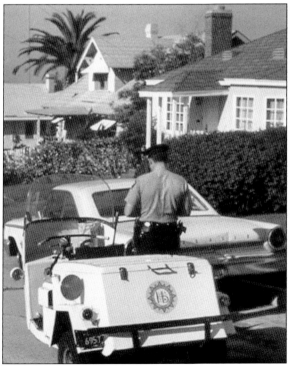

The Hermosa Beach parking attendant is an aggressive sort, with strong eyesight and hand-computer-punching skills, able to chalk-mark 100 tires in five minutes and cover great distances in a rattling, rebuilt washing machine on wheels. Many believe that the parking attendant is native to Hermosa Beach. But urban planners have argued that it evolved elsewhere and acquired its main characteristics in some nefarious metropolitan cabal back east. However, few will argue that the Hermosa Beach subspecies (*Ticketus adnauseumhorribilis*) is the most tenacious of all its kind. (Courtesy Hermosa Beach Police Department.)

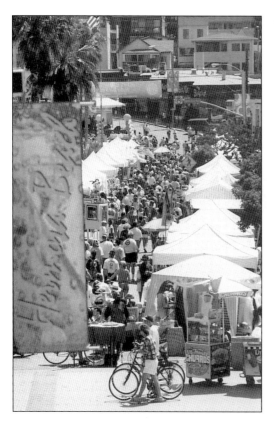

The Fiesta de las Artes dominates Hermosa Beach's Pier Plaza and lower commercial streets for two long weekends a year—Memorial and Labor Days—to bookend the summer season. Thousands of fiesta-goers make the annual stop for the Fiesta de las Artes from much further away than the limits of Los Angeles County. Art displays and sales, games, food, and throngs just interested in other members of the throngs come to enjoy the unique atmosphere in the city. (Courtesy Chris Miller.)

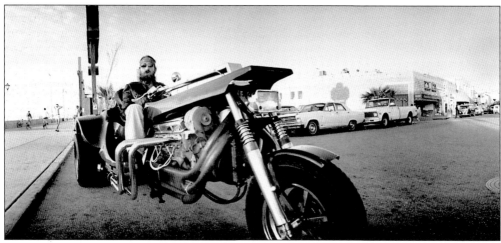

This is a whole-hog view of Pier Avenue at the Strand. Weekend bikers have been riding in and out of Hermosa Beach practically, it seems, since the day after someone put a motor on a bicycle. There was intermittent weeping and laughing when an entire row of motorcycles was toppled like dominoes in front of the Poopdeck Bar on the Strand in the Hermosa-lensed beach epic *Hardbodies* (1984), which was as humanly deep as its wardrobe and title. Hermosa is an equal-opportunity filming locale. Other celluloid marvels include the feature film *Charlie's Angels*, *The A-Team* (Hermosa was its location for car crunches), and beer commercials starring surfer Corky Carroll. (Courtesy Robi Hutas.)

"Surfing Santa" has been an annual yuletide ritual on the cover of *Easy Reader* for decades. Paul Matthies is seen here in the red suit. *Easy Reader*, based in Hermosa, has been a beach cities weekly for 35-plus years under the management, almost from the beginning, of editor/publisher Kevin Cody. The city's very first newspaper, *The Hermosa Review*, began perhaps in 1903 by Edward F. Thomas (according to historian Pat Gazin), was edited and published by Franklin H. Johnson from 1913. *The Hermosa Review* and the *Redondo Breeze* were both owned by S. D. Barclay beginning in 1908. Competition came from the *Redondo Reflex*. *The Breeze* became a daily in the mid-century. It was bought by Copley Newspapers, and exists today in Torrance as *The Daily Breeze*. It covers the entire South Bay. *The Beach Reporter* began operating in 1986, and under publisher Richard Frank became the *Easy Reader's* weekly rival, both with Thursday deliveries. (Courtesy Dwight Ueda/*Easy Reader*.)

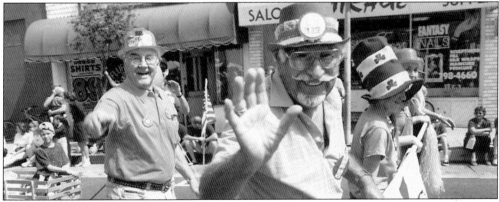

St. Patrick's Day is perhaps more of an annual rite in Hermosa Beach than most places. The downtown Irish watering holes include Patrick Malloy's, Hennessey's, and Fat Face Fenner's Faloon. In the old days, all the barstools were cleared out of the saloons by late afternoon to make room for all the merriment one city could (and occasionally couldn't) handle in a night. Pictured here are Kiwanis Club members Dr. Merle Fish (left) and Joe Diaz (in the foreground). (Courtesy Chris Miller.)

Valley Park is the city's largest park outside of the beach and the Greenbelt. It contains a soccer field, basketball courts, a children's play area, and a picnic area. The Hermosa Garden Club planted a native floral garden in the park. The club's activities included a successful campaign to save Greenwood Park, at Pacific Coast Highway and Aviation Boulevard, for the display location of the old Vetter Windmill (see page 17). (Courtesy Chris Miller.)

In September 1998, Hermosa Beach residents refused to stand for a renewed attempt to drill for oil underneath the city. Here protesters express their feelings at city hall. City council eventually decided to discontinue a 14-year battle and prohibit an oil company from drilling in the city. (Courtesy Chris Miller.)

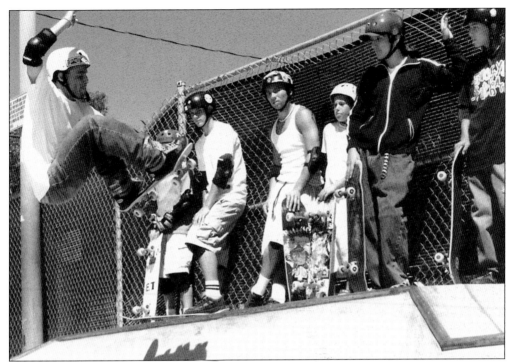

Hermosa Beach used to seem like the unmanaged and free-form Indianapolis of skateboarders with, of course, the pier apron an inviting spot to surf the concrete. But an effort in the 1990s to build an official city skateboard park at the former Pier Avenue School has allowed skateboarders their very own venue. (Courtesy Chris Miller.)

In 1996, the Hermosa Beach City Council ceremoniously brandished spade shovels for the groundbreaking of Pier Plaza. From left to right, they are Bob "Burgie" Benz, J. R. Revicsky, Julie Oakes, John Bowler, and Sam Edgerton. (Courtesy Chris Miller.)

The last block of Pier Avenue was converted in the late 1990s into Pier Plaza, creating an inviting gathering spot of restaurants, shops, and nightspots to cater to visitors and townsfolk alike. Occasionally musicians of all ages come out to provide a melody for the atmosphere. This nighttime shot of the plaza was taken at the foot of the pier. (Courtesy Chris Miller.)

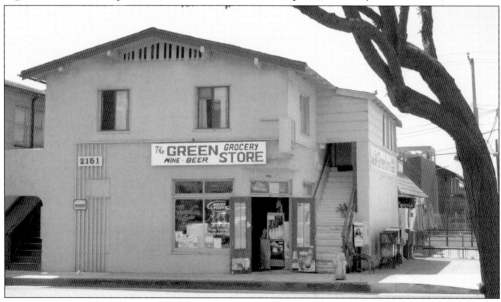

Around 1914, a Mr. Welcome U. Almond opened a store at Twenty-second Street and Hermosa Avenue. The location has served as the Green Store for generations since. Painted green, and with a remarkable array of potables, snacks, and sundries for its comparatively miniscule size, the Green Store has been a godsend to surfers, volleyball players, and other beachgoers for nearly a century. Other longtime corner markets in Hermosa neighborhoods include Mickey's, Granny's, and Bocato's. (Courtesy Chris Miller.)

Before it became known as The North End, this bar and restaurant had several names: Critter's, Esther's, The Carousel—which actually rotated on a circular device not unlike a merry-go-round. When the joint was Esther's, the back room was the Chi Chi Club, for the benefit of jazz aficionados. (Courtesy Chris Miller.)

In 2000, the USS Elliot, one of the Navy's Spruance-class strike destroyers, came by for a port-of-call visit to Hermosa. Warships also visited the coast at different times throughout the 20th century. Enormous oceangoing tankers can often be seen from Hermosa Beach as they ply the waves up Redondo Canyon, a deepwater passage in the ocean floor through Santa Monica Bay. The tankers off-load fuel at undersea pipeline connections off El Segundo. But rarely does a ship, yet alone a warship, come this close to Hermosa. (Courtesy Chris Miller.)

This typical Hermosa Beach "beach shot" looking south from the pier depicts a guard shack, breakwater, Goodyear blimp, Santa Monica Bay, and Palos Verdes Peninsula ("The Hill") in the far background. (Courtesy Chris Miller.)

To commemorate Hermosa Beach as the official birthplace of surfing in California, in 2001 the city created the Hermosa Beach Surfing Walk of Fame on the pier. This photo depicts the first seven local surfers inducted into the Walk along with 16 pioneers of the sport. The locals inducted were Bing Copeland, Hap Jacobs, Greg Noll, Mike Purpus, Jeff Stoner, Dale Velzy, and the great Dewey Weber. The pioneers were Doc Ball, Hop Swarts, LeRoy Grannis, Jim Bailey, Bill Edgar, Ed Edgar, Bob Bacon, Ward Baker, Mary Kerwin Riehl, Fred Kerwin, John Kerwin, Ted Kerwin, Jim Kerwin, Al Holland, Paul Matthies, and Cliff Tucker. At the microphone is Hermosa city councilman Sam Edgerton. The event was attended by thousands who jammed the streets. (Courtesy Chris Miller.)

This group of hula dancers at water's edge performed a welcoming dance for King Neptune to kick off Aloha Days, an annual Hermosa festival. Pictured here in 2002 are 25 girls in authentic Hawaiian costumes and headgear, with the Hermosa Beach Pier behind them. (Courtesy Chris Miller.)

This might be considered a *Baywatch*-like image for someone in another part of the country—with a guard shack and sunset in the background. In South Bay, where a lot *Baywatch* was filmed, this is considered a very Hermosa Beach–like image. (Courtesy Chris Miller.)

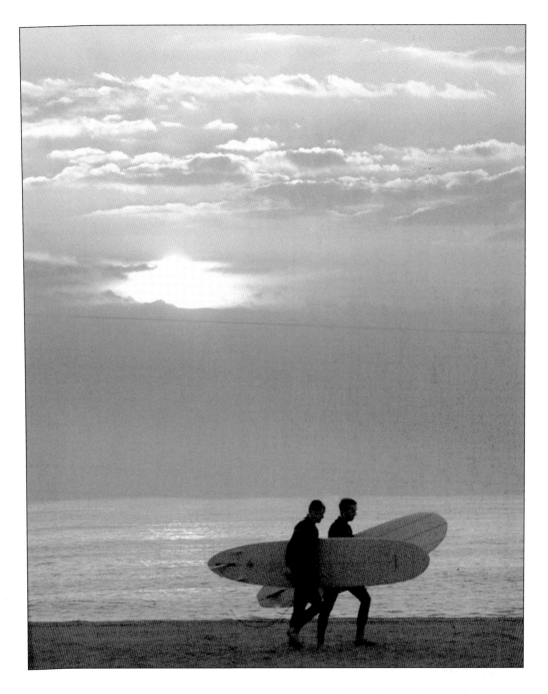

ABOVE: Sunset in Hermosa Beach brings a sense of tranquility to the sand as most beachgoers, including these surfers, call it another day—another day in paradise. (Courtesy Chris Miller.)

OPPOSITE: The Farmer's Market comes to Hermosa Beach's Clark Stadium every Friday. The tomatoes, celery, and fruit are all fresh, as is the wafting sounds of a saxophone player or two. Here veteran and novice alike are ready for a jam session. (Courtesy Chris Miller.)

BIBLIOGRAPHY

Ball, John "Doc." *California Surfriders: A Scrapbook of Surfriding and Beach Stuff.* Hermosa Beach, CA: John Ball, 1946.

Cody, Kevin. "Beautiful History." Insert, Hermosa Beach, CA, *Easy Reader*, August 1997.

Dennis, Jan. *A Walk Beside the Sea: A History of Manhattan Beach.* Manhattan Beach, CA: Jan Dennis, 1987.

Gazin, Patricia A. *Castles in the Sand.* Hermosa Beach, CA: Myron Gazin, 1991.

———. *Footnotes in the Sand: An Incomplete Compendium, an Arbitrary Selection of Events, Rumor, Speculation, Some Fiction and Some Fact About Hermosa Beach.* Hermosa Beach, CA: Patricia A. Gazin, 1977.

Gazin, Patricia A., Josh Hallett, and Naoma Valdes. "Time Line." Insert, Hermosa Beach, CA, *Easy Reader*, August 1997.

Hales, John T., editor. "Hermosa Beach Timeline: 'Time Periods,' 'Time Lines,' 'City Documents,' 'City History,' 'People,' 'Happenings: Ongoing,' 'Happenings: War,' 'Churches,' 'City of Hermosa Beach,' 'Police Department,' 'Fire Department,' 'School District,' 'U.S. Census,' 'Real Estate,' 'Organizations,' 'Maps,' 'Neighborhood Committees,' 'Oddball,' etc." Hermosa Beach, CA: John T. Hales and the Hermosa Beach Historical Society, 2002–2005 and continuing, 35-plus volumes.

McCawley, William. *The First Angelinos, the Gabrielino Indians of Los Angeles.* Banning, CA: Malki Museum Press/Ballena Press, 1996.

Rhein, Fern. "The Early History of Hermosa Beach, California." Hermosa Beach, CA, July 30, 1933: 25 pp.

Roberts, Jerry. "Comedy & Magic Club Stands Up to the Best." Torrance, CA, *Daily Breeze*, August 15, 1986: E23.

———. "The Lighthouse: Then & Now." Torrance, CA, *Daily Breeze*, September 5, 1986: E1.

Rodaway, Edith, and edited by Rev. Virginia H. Benson. "The St. Cross Story: St. Cross Episcopal Church." Hermosa Beach, CA: St. Cross Historical Committee, 1994.

Scheerer, Lorietta Louise. *The History of the Sausal Redondo Rancho.* Los Angeles: Master's Thesis, University of Southern California, 1938.

Shoemaker, Mark. "Definition of Historical Character." Hermosa Beach, CA: Hermosa Beach Historical Society, October 2004.

Tatum, Donn Benjamin Jr. *The Rancho Sausal Redondo.* Los Angeles: University of Southern California, Master's Thesis, 1968.

Warshaw, Matt. *The Encyclopedia of Surfing.* San Diego: Harcourt, 2003.